DRAW ANYTHING

★ *with* ★

FELT-TIP PENS & MARKERS

To my parents, who are both art teachers & always wonderfully encouraging (even of my mistakes!).

An Hachette UK Company
www.hachette.co.uk

First published in Great Britain in 2017 by Ilex, a division of
Octopus Publishing Group Ltd
Carmelite House
50 Victoria Embankment
London EC4Y 0DZ
www.octopusbooks.co.uk

Copyright © Octopus Publishing Group Ltd 2017
Text and illustrations copyright © Holly Wales 2017

Publisher: Roly Allen
Editorial Director: Zara Larcombe
Managing Specialist Editor: Frank Gallaugher
Editor: Francesca Leung
Admin Assistants: Sarah Vaughan, Stephanie Hetherington
Art Director: Julie Weir
Designer: Ginny Zeal
Production Controller: Meskerem Berhane

ISBN 978-1-78157-436-2

A CIP catalogue record for this book is available from the British Library.

Printed and bound in China

10 9 8 7 6 5 4 3 2 1

DRAW ANYTHING

with

FELT-TIP PENS & MARKERS

By Holly Wales

ilex

CONTENTS

INTRODUCTION

You might have relegated felt tips both to the bottom of the pencil case and in your mind – long since forgotten and surpassed by your gel and ink pens, even for doodling on notebooks. Or if you like colouring-in books or have a passion for stationery you might have a nice collection of felt-tip pens, but aren't sure what else they are good for. This book is all about giving you ideas, tips and inspiration to take you to the next level when it comes to drawing with felt tips and marker pens.

If you don't have a set of felt tips, then you can find a set easily – felt-tip pens are available everywhere and in as many colours as you can imagine. You don't need anything fancy to start with and water-based pens are best for a beginner (solvent-based pens can bleed through paper and ruin your hard work on the other side).

I have been drawing with felt-tip pens for as long as I can remember. As a kid, my mum and I would sit at the kitchen table and draw with them together. I found it inspiring to see what a grown-up could do with the same basic tools as I was using. Years later as a penniless art student, I was limited in the materials I could afford, but thanks to the humble pound shop there was always a supply of fibre-tipped coloured options to hand. I began life as a felt-tip pen connoisseur with the cheapest – a pack of 36 pens with clear plastic caps with air holes in them that would often dry up within a month or two. As I began to embark on the world of freelance illustration, I sought out better quality pens until I discovered brush pens and everything changed;

they give the closest effect you can get to paintbrushes. Nowadays I tend to use a dual-ended brush pen by a Japanese manufacturer called Tombow. But I'm not loyal to any particular brand. I'm more of a magpie – whatever works best for the task!

This book isn't really a 'how to draw – full stop' kind of book – there are hundreds of those available, some dedicated to entire species of animal! Instead, this book assumes you have a bit of knowledge about how drawing works and that you just want to have fun and explore some new materials and techniques.

All you need is some pens and plain paper (don't use too small a size of paper though, as it gets tricky to handle detail with felt tips on a small scale). Some of the exercises also require a pencil, a pair of scissors, coloured papers and a pack of erasers. I'd recommend starting off by looking at the 'Drawing Tools' page which talks you through some of the different felt tips and marker pens on offer, and the effects they can achieve. Also check out the 'Tips & Tricks' page for my advice on how to get the best results.

The important thing is to relax and see where your pens take you. It's a rewarding journey, I promise. The rest is up to you!

HOLLY WALES

DRAWING TOOLS

Felt tips come in a huge range of colours – and you can try them all! It's up to you what kind of pens you use but I recommend starting off with a small collection of different types to experiment with and see what works best for you. Some people prefer the textures you can achieve with fine-tipped classic felt-tip pens, often used in schools, and others prefer the more painterly textures that solvent-based brush markers offer (such as ProMarkers and Copic Markers). Some of the exercises in this book suggest a specific type of pen to help you explore techniques.

Permanent markers come in lots of different sizes – medium-weight ones are perfect for layering up areas of colour and adding texture if applying darker colours on top of lighter ones. But beware of how much they can bleed through your paper – you might find you enjoy the special effects you get on the reverse, or you can put a blank sheet behind your work to soak up some of the damage!

Extra fine pens are handy for working up your drawings and adding small details. They are also good for drawing line work.

Brush pens are great because they give you the feeling of painting but with the qualities of felt tips. You can easily alter the pressure you apply to the tip for a variety of effects. Some sets include a clear pen that you can use for blending before colours have completely dried. Brush pens are also handy for exploring brush lettering, a style inspired by traditional sign painting.

Chisel-tipped marker pens aren't available in as many colours as other pens but are useful for blocking out large areas of colour or creating an italic slanted line. They tend to be solvent-based and use stronger pigments so you may find they bleed through paper a lot more than other felt tips.

Chalk markers come in a variety of sizes from fineliners to chunky markers. They give an opaque texture that looks like liquid chalk and, although they don't produce very vivid colours, are great for drawing onto coloured paper or over drawings. If you only buy one of these, make it a white one as it has the most uses.

Broad felt-tip pens are good for when you have a large area to cover, but there is the tendency for the ink to sink into the paper and bleed through to the other side. They're not as sensitive to pressure as brush pens, but this means they will last longer and you're also less likely to damage the tip by pressing too hard.

TiPS & TRiCKS

* Felt tips and marker pens work best on a smooth or shiny surface. I would recommend something like Bristol board which is a really crisp white paper and a great surface for colours to sit on. I like seeing the watery, inky textures in the pens, and Bristol board picks these up well. Avoid absorbent papers such as those made for watercolours – they'll drain your new pens dry in a matter of days and colours appear much darker.

* Felt tips can stay wet for a while – this is great for blending colours, but not so great for when you want to avoid smudging. For smudge-free work, try drawing from left to right across the page (flip this advice if you're left handed of course) – that way, you'll never be leaning on what you've just drawn. The same applies vertically on the page – start at the top and work your way down.

* Sometimes the 'felty' bits at the tip of the pen can build up and leave scratchy double lines – this tends to happen when the pens get a bit older, but you'll find they still have plenty of life in them. You can usually smooth them down or pick off enough of the felt bits with a finger to improve the line (or, if you're careful – use a scalpel for precision!).

* Sometimes having access to a wide range of colours can be a bit overwhelming. Try limiting yourself to a smaller range of colours before you start – these can be similar or contrasting ones – the effect of using a fewer number of colours can often be a lot bolder. Play around with just one, two or a handful of colours and see how it can change the mood of your drawing.

* Drawing from life gives you a better understanding of what things really look like. It's more accurate to draw from life than from a photograph – and while life-drawing classes are pretty cheap and easy to come by (don't forget to take your pens along!), drawing from life can also apply to drawing inanimate objects, animals and landscapes too. If you're drawing from life regularly then you're less likely to get too caught up in the impact of a particular mark or stray shape.

* The best advice I've ever been given is not to be too critical of a drawing while you're making it – leave all the analysis for the end, and then use it to get started on something else. It's a good formula for making pictures.

* Felt tips are ultimately a fun medium to work with – don't worry too much about making mistakes, you might even come up with an interesting effect by accident!

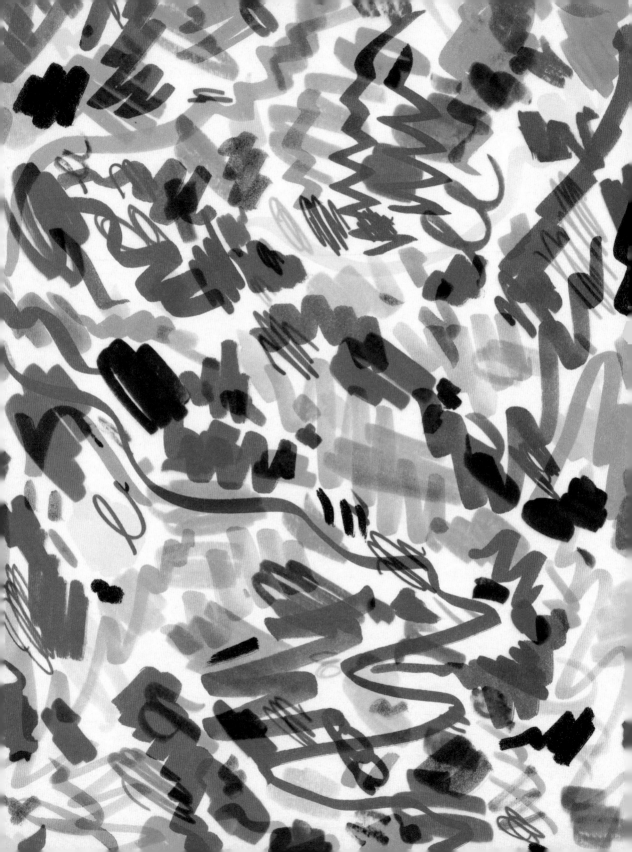

TEST YOUR PENS

Whenever I'm starting a new project, I like to get all my pens out and test them. I am pretty ruthless with this – any that are completely dried up go in the bin, the fading ones go in a pile that I'll use to create textures with and the good ones rattle around together in a box!

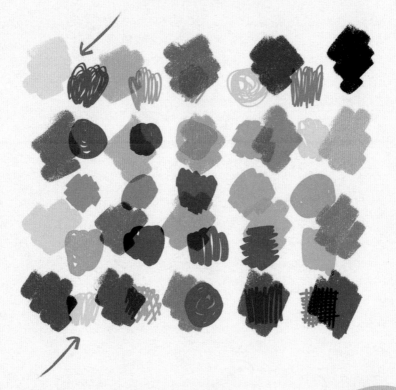

Just have a play – take a blank page and test every pen you have until the page is completely full, and don't be afraid to go off the edges of the paper or layer things up. It is also a good exercise in developing a real energy with your drawing technique – make broad strokes, draw fast, don't worry about being neat or staying within the lines (because there aren't any!). It's a great way to see which colours work well together and how different lines can be combined.

Tip

This is also a good opportunity to see which colours will layer up on top of each other without disappearing or looking murky.

UNDERSTANDING COLOUR

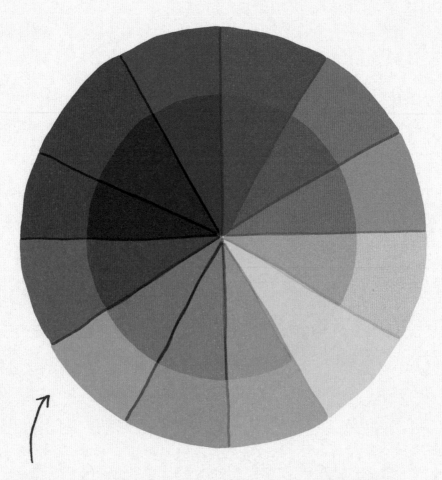

This colour wheel gives you an overview of how colours are connected to one another. You can see at a glance which colours are opposites and therefore contrast, by seeing which ones directly face each other on the wheel. For example: purple and yellow, blue and orange, red and green. In the same way, colours that are grouped next to each other on the wheel complement each other, such as blues and purples, blues and greens, oranges and reds.

Once you start drawing and shading with your pens, you'll see how you can achieve a basic form of colour mixing – you won't get as large a range of colours as you would with paint or ink, but there are still plenty of possibilities.

Try and get your hands on a set of felt tips that has as many colours as possible to begin with; this will help you learn about choosing and mixing colours through your own experimentation.

Try putting all of your blue pens together (of all different thicknesses and types) and you'll quickly see what a huge range of tones are available to you in just one colour!

iDEA

If you arrange your pens by putting them into colour-groups, you'll notice that not all colours are created equal – a blue pen can be a bright blue, a light blue or a purpley blue.

BLENDING COLOURS

It has to be said, felt tips aren't the best medium in the world for blending colours. They're not a patch on watercolours or water-soluble crayons, for example, and if you try to mix too many felt-tip colours together you'll end up with a dark sludge (and maybe a hole in your paper).

But blending felt tips is possible! You might find it slightly easier if you have a transparent blending pen in your collection as it acts a bit like water for watercolours.

TIP

You can use your finger
to smudge colours together
if the ink is still wet.

You can blend two similar colours together directly or you can also
add a mid-tone between them to make the blend appear smoother.

Put down the darker colour first, then add the lighter colour next
to it (but not quite touching) and use either the lighter colour or
the mid-tone to join the two up.

BASIC TEXTURES

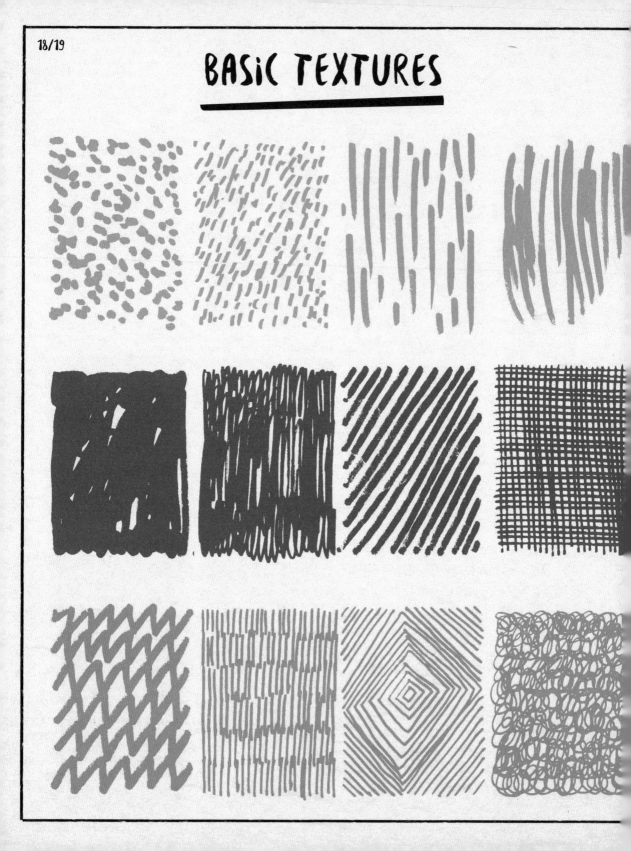

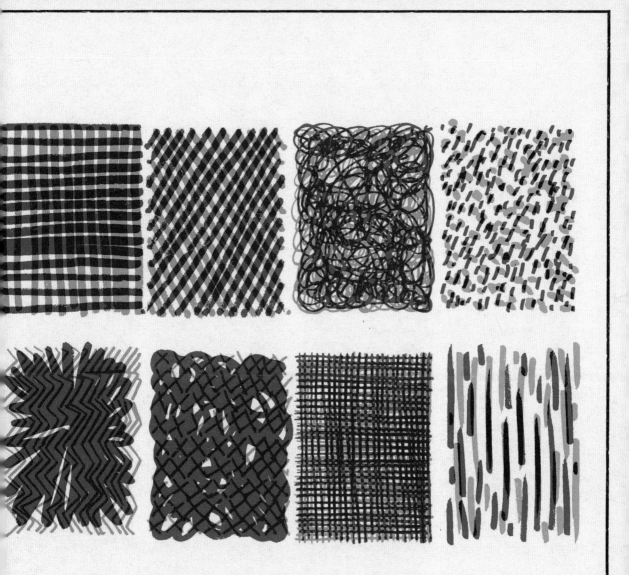

You'll soon find your own ways of making marks with felt tips and marker pens as you experiment with them, but here are a few to get you started.

* You could use one pen to make a texture or combine two of the same colour in different thicknesses.

* Or combine two different colours using the same pattern.

* Or two different colours in different patterns!

Try out some of these and see which you like best.

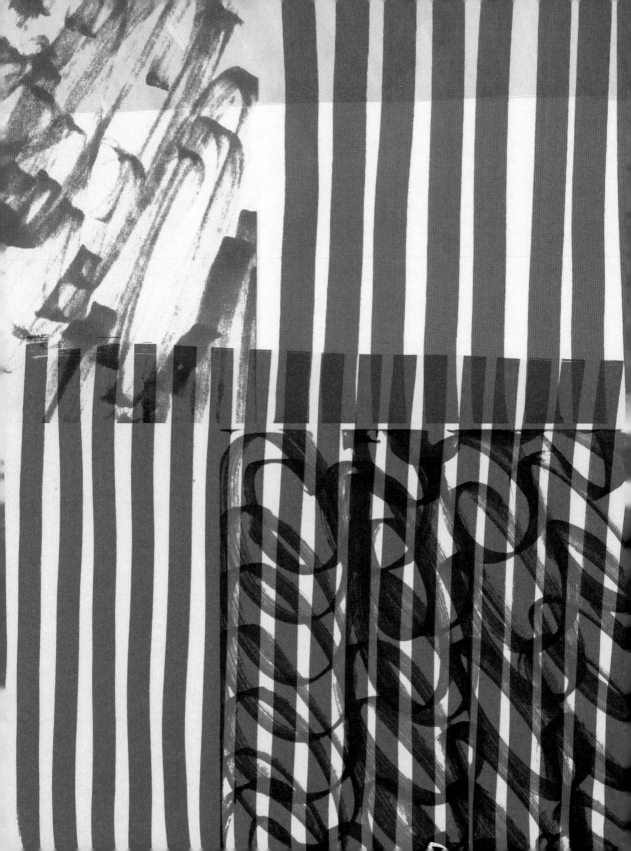

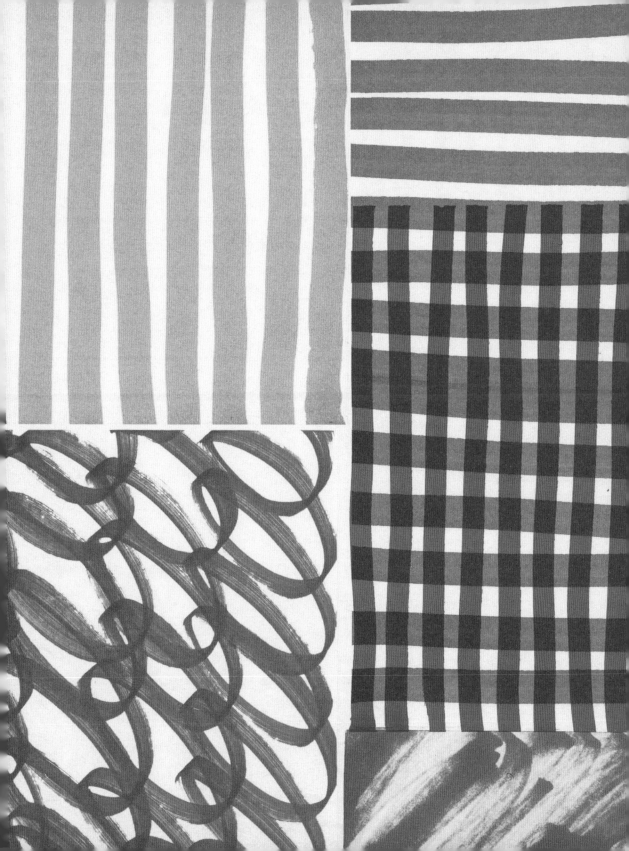

BLACK & WHITE PATTERNS

Felt tips and markers may come in every colour imaginable, but there's a lot you can do even if you limit yourself to just one colour. This colour can be anything, but I'm using black here because I like the contrast between it and the paper – it really makes your patterns pop!

These patterns are intended as a guide to introduce you to the power of black and white or monochrome. Your designs could be big or small, repeat or one-off. They could be as simple as drawing one shape, and then repeating it over and over again in the same colour until you see your pattern emerge. You could use lots of black pen and leave only some small areas of white visible, or hardly make a mark at all. Try copying some of these patterns here to get you started.

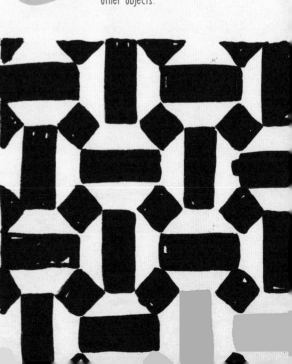

IDEA

These patterns are fun on their own or you could think about adding them as details onto drawings of clothes or other objects.

GEOMETRIC PATTERNS

Felt tips and marker pens can be used to produce blocks of flat colour in one tone, making them perfect for creating bold, geometric repeat patterns. Play with simple shapes such as squares, circles and triangles to create your own design. Then draw them again and again!

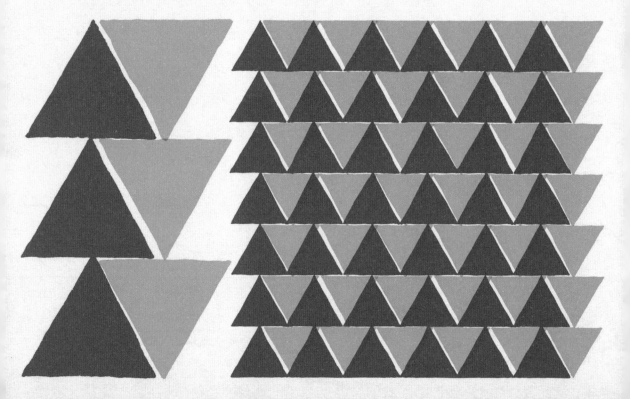

TiP

Overlap some of your shapes to get areas of darker colour, and space out some of your other shapes to let parts of the paper show through.

iDEA

If you draw enough shapes, you can create your own wrapping paper. A sheet of wrapping paper is typically 50 x 70cm (28 x 20in), but if you're not feeling that adventurous you could always make a smaller sheet to wrap a smaller gift! You could also scan your drawings and make a repeat pattern using Photoshop instead.

MORE GEOMETRIC PATTERNS

The possibilities for the kind of geometric shapes and patterns you can create with felt tips are endless. Don't be afraid to switch things up and change your colours, even if you don't change your shapes. You can pick colours at random depending on how you feel, or you can take a more methodical approach by choosing colours in advance and making a little plan of which shapes will be which colour.

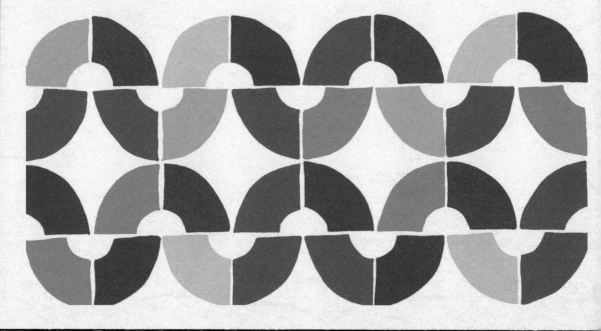

TIP

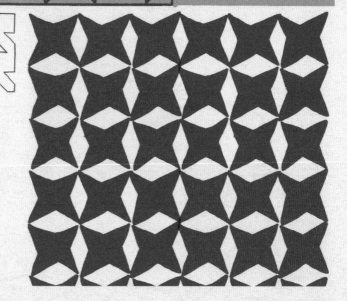

You can easily make your patterns seem much more complex than they really are. Here I have isolated the shape I designed before I coloured it in – all I've done is drawn it over and over again, connecting each block to the one next to it, then coloured each one in the same colour to blend the pattern seamlessly. See if you can work out how my other patterns have been made using the same trick.

GRAPH-PAPER PATTERNS

Drawing on graph paper is great if you are a bit daunted by big white pages as it gives you a structure to get started with. Think of it as another kind of colouring-in book, except you get to call all the shots.

Try creating repeat patterns or one-off designs – how big can you make them? Experiment with some recognisable images like these heart or cross icons, as well as more complex decorative patterns to really stretch your skills.

TiP

Graph-paper is readily available from any stationery shop, or there are even websites where you can download and print your own if you're in a hurry to get started!

Think about your choice of colour palette too. By choosing complementary colours from a similar place on the colour wheel you can create a more cohesive pattern (I've gone for greens here – from greeny yellows at one end of the spectrum, through to greeny blues at the other.) Alternatively you can choose clashing colours on purpose for contrast!

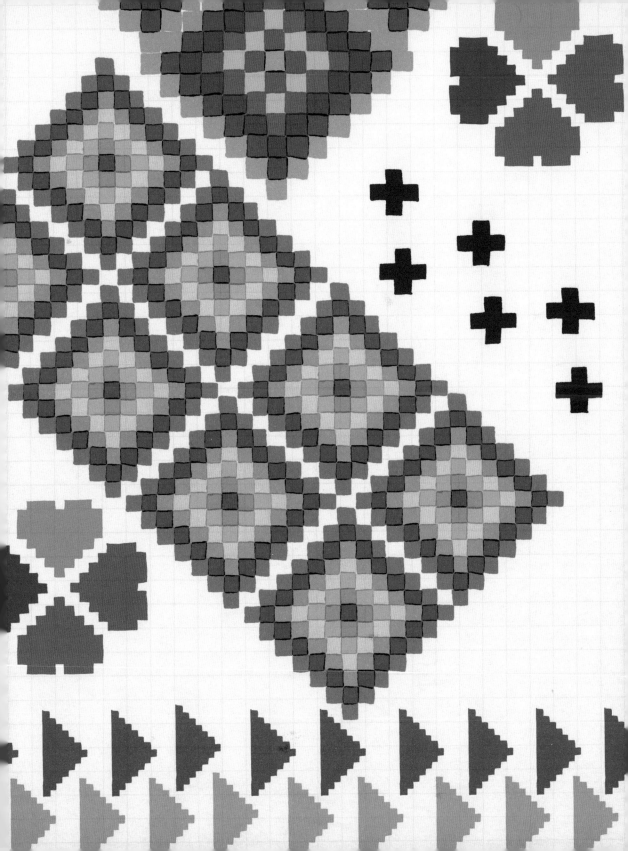

HAND-DRAWN NUMBERS

Numbers are everywhere! From the date you were
born to how many bananas you'll eat in your lifetime.
We use them a lot, and they don't need to be consigned to
maths text books; you can make them beautiful and decorate your own!

Mixing up your choice of colours is a good way to make humble digits
more interesting – add a contrasting background colour or play with the
colour of each number in a sequence. Don't worry if you go over lines
or if colours overlap – it's all part of the joy of felt tips.

iDEA Big brightly coloured numbers are perfect for birthday cards
– how about designing your own? You could even add some
hand-drawn type to go with them (see pages 58 and 124).

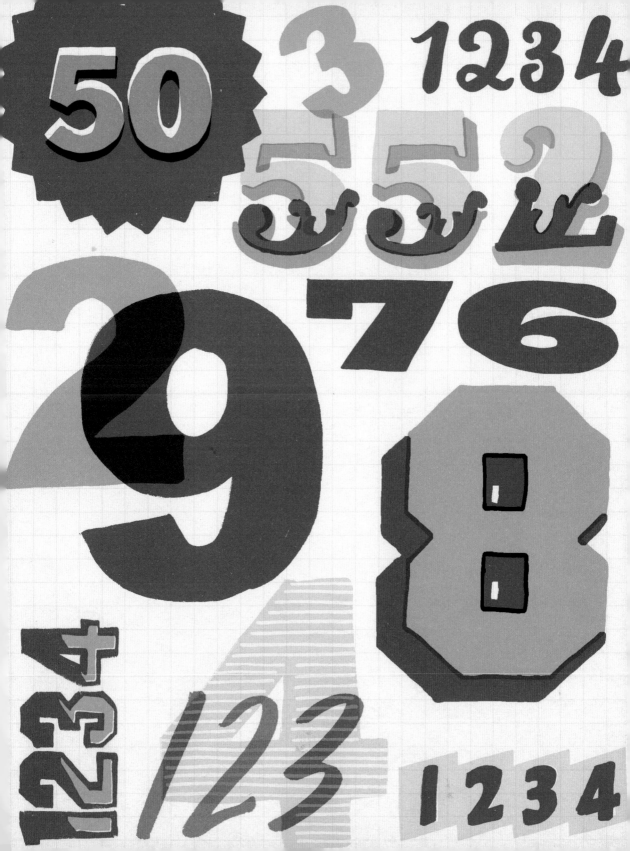

ULTIMATE DOODLER

Line up a long phone call with a friend and have your paper and pens at the ready – pick your favourite felt tips as you're about to take on the biggest doodle of your life! Here are some ideas on how to take your doodling to the extreme.

Start anywhere you like on the page and keep on drawing without taking your pen off the paper until the page is full. Try layering lots of doodles on top of each other in different colours.

For this teardrop doodle, you start by drawing one teardrop, and then adding more and more around it at different angles to fill up the space as much as your paper will allow. It's the perfect way to decorate your stationery!

iDEA When all your lines are drawn, you can start to fill in some of the new shapes you've created with colours or even patterns.

DOODLE PATTERNS

Repeating patterns don't always need to follow a strict set of rules for how they should repeat. You can have just as much fun drawing shapes that don't follow a template, embracing all the wonky lines along the way!

Start with a pattern based on basic shapes such as circles and triangles and try drawing them slightly differently each time you repeat them so that the pattern evolves as it moves across the page. Deliberately make some shapes bigger than others – this will give the overall pattern plenty of variation and interest. Here are some examples to get you started.

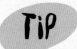 **Tip** Play with the line that your shapes sit on – it doesn't have to be straight!

Tip Think about patterns within patterns – use your finer pens to add detail.

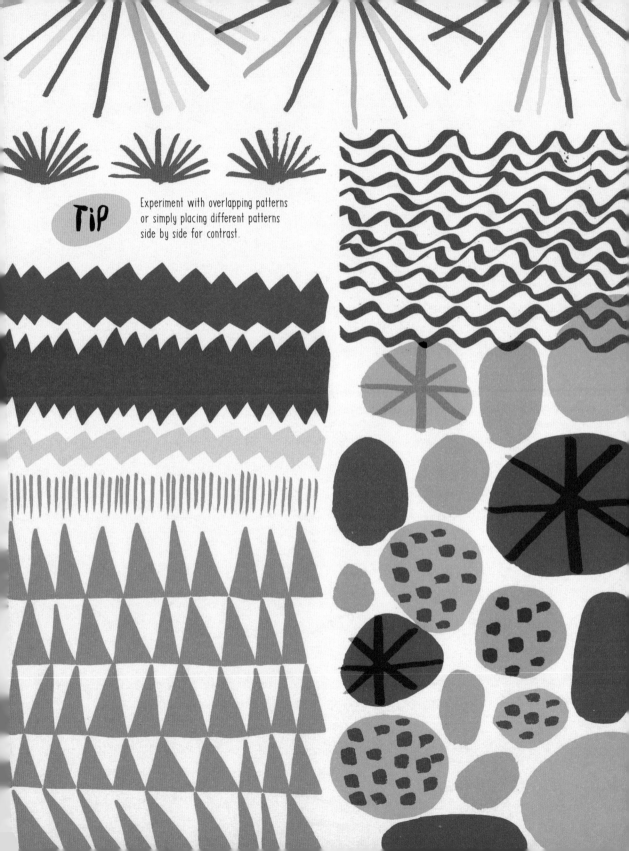

TiP Experiment with overlapping patterns or simply placing different patterns side by side for contrast.

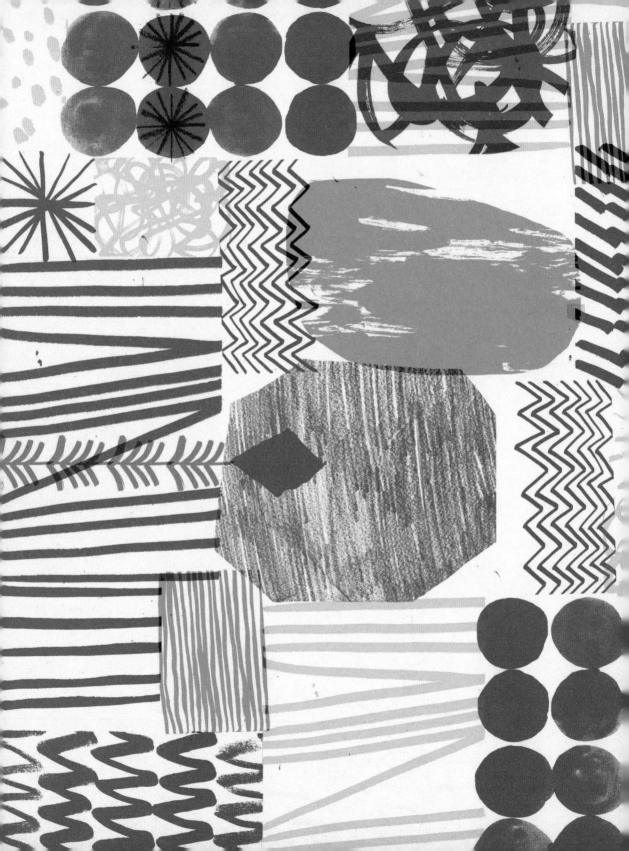

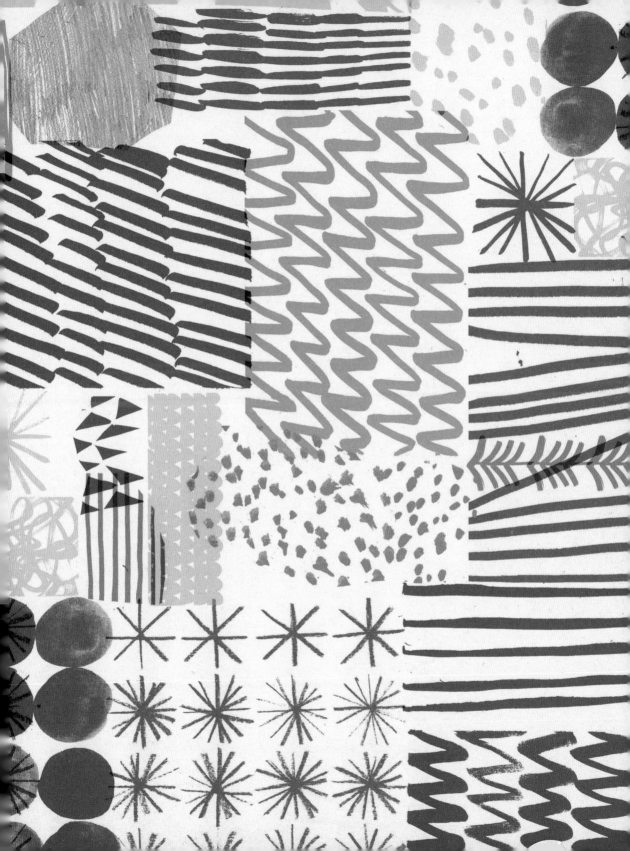

DRAWING CATS & DOGS

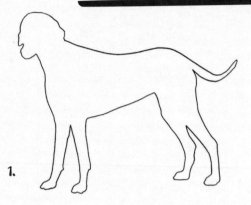

1.

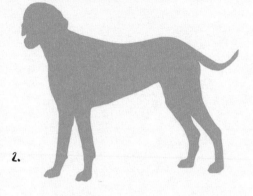

2.

1. Start with an outline of your favourite hound in pencil, or dive straight in using a light-coloured pen.

2. Fill in the outline with a broad or brush pen in a light colour (or the same shade as the pen used for the outline).

3. Draw in the dog's markings and features over the filled-in silhouette using a darker pen. Don't worry about outlining every individual body part – just add suggestions of lines wherever you think they're important (for example where a leg joins the body).

4. Voila! (Or, er, woof!).

You don't have to draw every single marking on your pet – just a few spots or stripes here and there can be enough!

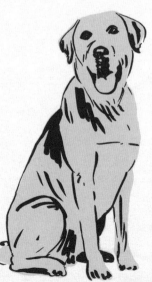

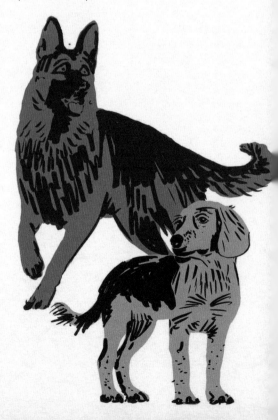

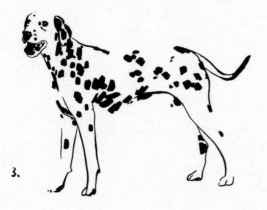

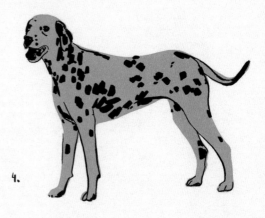

3.

4.

You can of course follow the same steps to draw cats instead, or any other pets!

Experiment with colours – your felt-tip furry friends don't have to be the same colours as they are in real life. Maybe Bertie the basset hound has always fancied himself in fluorescent pink?

HAIR & FUR

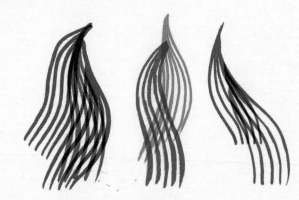

Hair and fur are not as difficult to draw as they seem. A basic trick is to start the parallel lines at a single point and leave them spread out at the other end. Then you can group this shape, repeat and rotate it to build up locks of hair.

Fur is drawn in a similar way to hair, but with much shorter strokes – think stippling and repeated wavy lines. You can also get a denser effect by layering two colours one on top of the other.

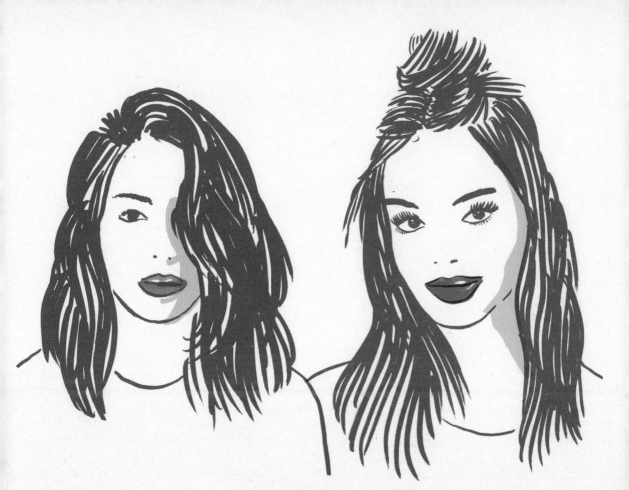

TiP

Hair changes direction all the time!
Look at the two examples above – the
parallel lines often go at right angles to
one another (especially at the parting).

HOW TO DRAW FIGURES

There are countless books available specifically on how to draw figures and although this is not an exhaustive guide here, I've outlined the basics so you can get started with your pens. I would recommend finding a photo to work from, or drawing a friend from life (if you can get them to stand still for long enough!).

Start by sketching out a basic form, showing the shape of the shoulders, stance and position of the head, arms and legs. Then re-draw this using block shapes to fill out the body – think curvy shapes for women, flowing skirts and long hair, and think more angular shapes for men, crisp shirts and tailored garments. You'll make progress more quickly if you practise drawing figures over and over again – getting them right first time is pretty much impossible so don't be too hard on yourself.

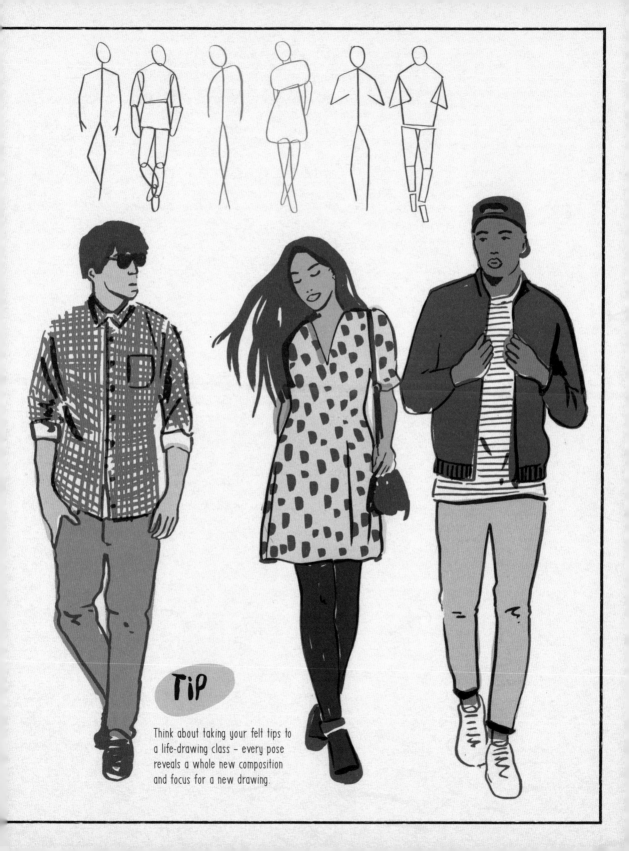

TiP

Think about taking your felt tips to
a life-drawing class – every pose
reveals a whole new composition
and focus for a new drawing.

FASHION ILLUSTRATION

Now you can use your felt tips to bring to life all the clothes you wish you could own! Drawing clothes with felt tips is really easy as you can use brush pens to suggest where fabric folds or pleats. Turn your brush pen on its side and apply hardly any pressure to draw uneven parallel lines to show folds in fabric and give it a sense of movement.

One way to draw a fashion illustration is to sketch out a basic line drawing for your figure first, then fill in the details; gradually add garments one at a time and add the skin in the places where you see it (as below).

Another way is to sketch out your basic form and block shapes in the same way you learned in 'How to Draw Figures', then filling in the details and adding colour.

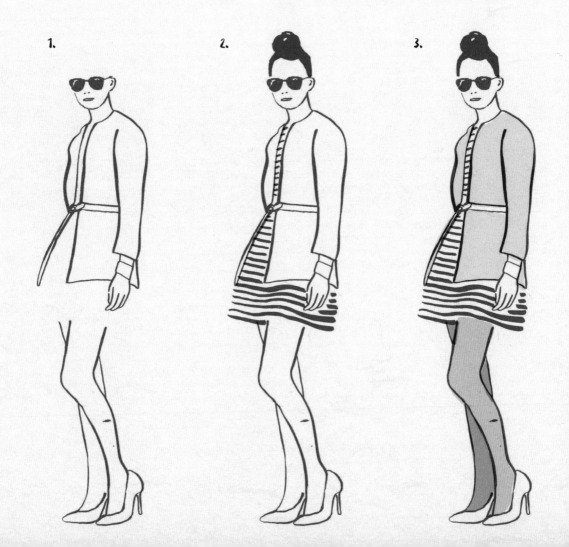

1.

2.

3.

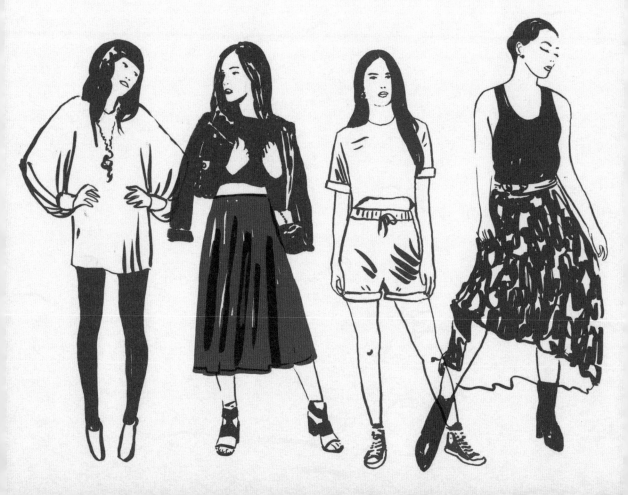

Explore lots of different line work before you start drawing clothes – most fabrics can be replicated by using some of the techniques shown in 'Basic Textures'.

MORE FASHION iLLUSTRATiON

Fashion magazines and blogs are good places to look for inspiration for your drawings. Use a brush pen to quickly jot down the main shapes and lines of the figures you want to draw. Add some 'Basic Textures' to pick out specific details such as T-shirt prints or patterns on bags and tights.

Turn your brush pen in your hand as you draw, pressing harder on one side for a thicker line, and releasing pressure on the tip for finer details or a flourish at the end of a line.

Tip

When you're drawing fashion illustrations, the emphasis is on the clothes, so you can just draw hair as a solid block, leaving a couple of highlights in the blocked-out area to mimic reflections in the hair.

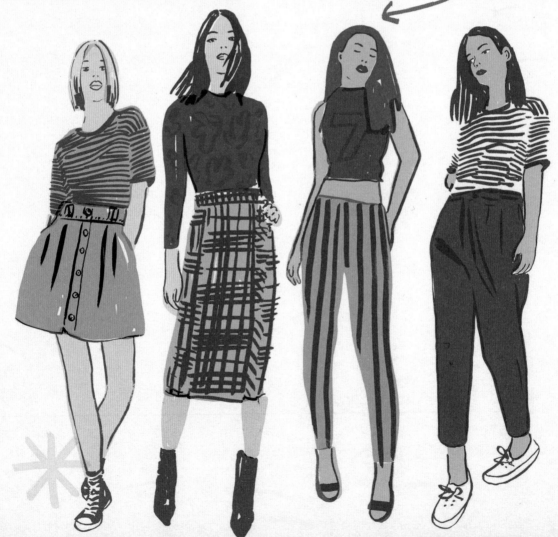

TIP

You don't always need to outline everything in a darker colour - just block out solid areas of colour to show each garment instead and use your line work for folds and patterns!

FASHiON ACCESSORiES

Add some bling to your drawings with some accessories: necklaces, earrings, make up, bags – whatever you like! Draw from your own collection or have a look through your favourite magazines for ideas.

1. **2.** **3.**

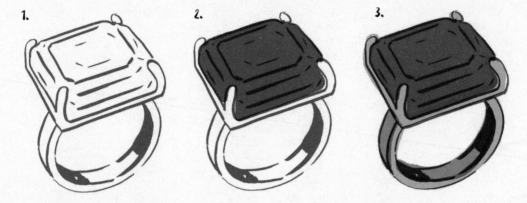

1. Jot down a simple line drawing of your item and mark in the details and shadows in a dark colour, so that they will show up when you colour over them in a lighter shade later. Your drawing doesn't have to be a photo-realistic representation – but keep looking back at the item for accuracy.

2. Add the first layer of colour – choose shades lighter than the line work, but not the lightest.

3. Finish off by adding highlights in your lightest shade of colour – yellow pens are great for this as their pigment is naturally bright.

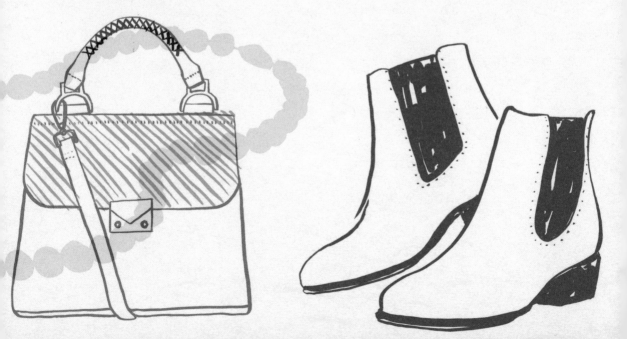

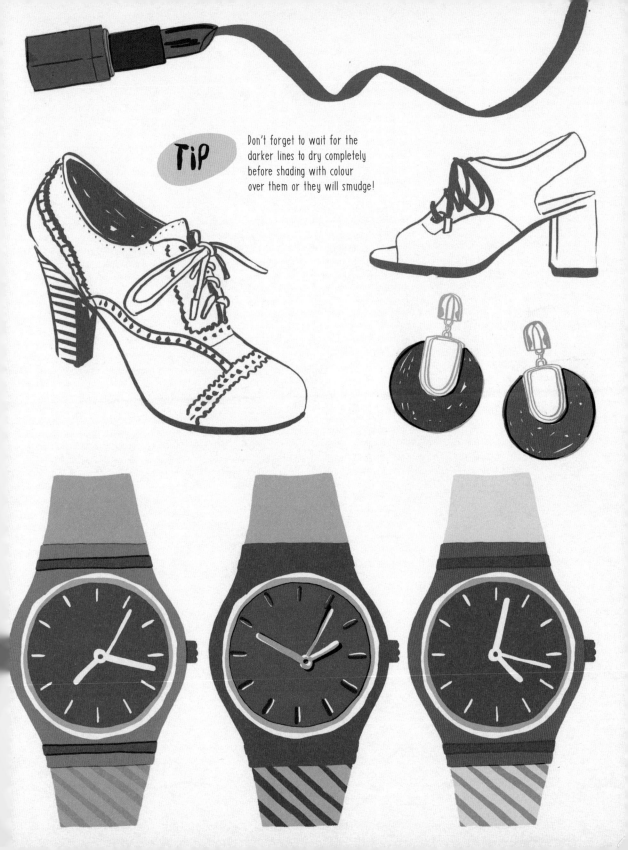

TIP Don't forget to wait for the darker lines to dry completely before shading with colour over them or they will smudge!

DRAWING BIRDS

Birds are really fun to draw and you can make them as colourful as you like. Start by drawing the outline of your bird in a light colour and then filling it in with the same colour to create a silhouette. You can also experiment with drawing some parts of the silhouette in a different colour, such as the claws or beak.

Then add the details in a darker or contrasting colour on top. Try to overlap some colours and not others, or deliberately go outside the lines – this will make your bird seem more animated.

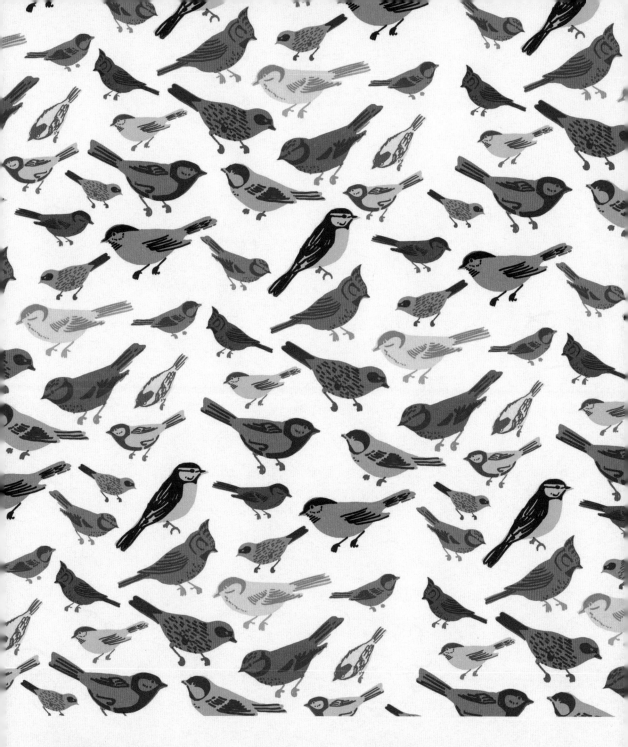

 Try drawing a few different birds then repeating them to make your drawings into a pattern – maybe you could design your own wrapping paper and wrap a present for a bird-loving friend!

 When making a pattern, play with the scale of some of your birds – some of them can be really big, and some tiny – to give your pattern movement and make it look more dynamic.

STEP-BY-STEP FLOWERS

1. **2.** **3.** **4.**

Drawing flowers with felt-tip pens couldn't be easier! You start with bold shapes and add as much or as little detail as you like. Start by making a list of your favourite flowers and finding photos of them in books or online. Or draw them from life if you can!

1. **2.** **3.**

iDEA

A hand-drawn felt-tip flower can make a great birthday card. Try drawing lots of flowers in different ways until you have something you're happy with, or maybe you could try drawing an arrangement of them in a vase if you wanted to try something more ambitious!

1. 2. 3. 4.

Don't be afraid to layer one colour on top of another, but make sure you start with lighter colours if you're planning to add darker details on top – light felt tips won't show up on dark backgrounds. Pens are quite inflexible when it comes to this (compared to more opaque media, for example gouache or poster paint), but once you embrace this limitation you can find creative ways around it. You don't always have to be literal in your use of colour – why should stems be green when they can be purple?

TIP

When you're drawing flowers and plants, you can scribble quickly and make interesting textures to represent petals, stalks, seeds or other plant attributes.

1. 2. 1. 2.

FLORAL PATTERNS

Now you know how to draw felt-tip pen flowers you can make your own floral patterns! Here you will learn some basic ways to make flowers into repeat patterns to try out with your own drawings.

TiP

Drawing repeat patterns is a labour intensive job and can take a while to get results. They will be worth it, but if you don't want to draw your flowers over and over again, you could always photocopy your drawings, cut them out and collage them. Or you can also try scanning them and repeating them in Photoshop instead.

This is one tile of the pattern isolated from the rest of it – if you look carefully, you can see how the pattern is made of up this tile.

This pattern is known as a 'half-drop repeat' – it looks complicated but you can do this yourself quite easily! First each of the flowers used in the pattern is drawn in a strip downwards, but whereas for a normal block repeat pattern that simply repeats in straight strips each time, a half-drop repeat drops down for every alternating vertical strip to give a zigzag pattern. Then it's just a case of layering all the flower half-drop repeat patterns on top of each other to make the more complicated-looking design!

Block repeat pattern:

Half-drop repeat pattern:

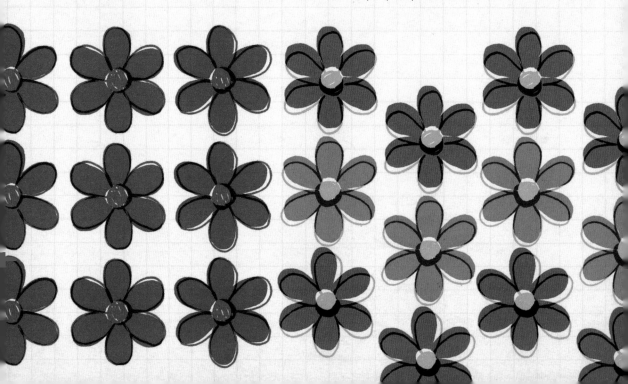

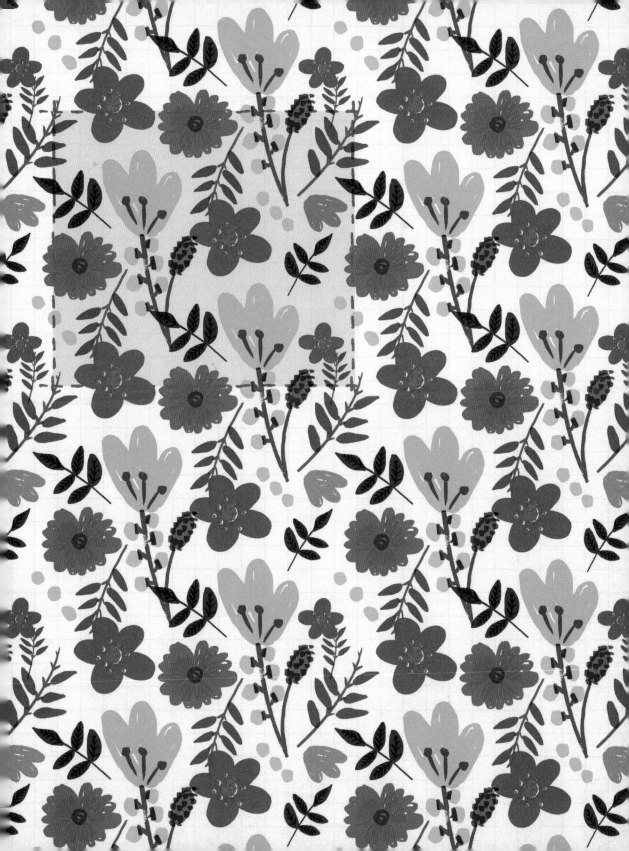

DESIGN YOUR OWN TOTE BAG

Have a go at designing a bold print for your very own tote bag using some of the felt-tip techniques from this book. The designs you come up with make fun drawings in themselves, but you could also invest in some fabric pens to transfer your designs onto real bags!

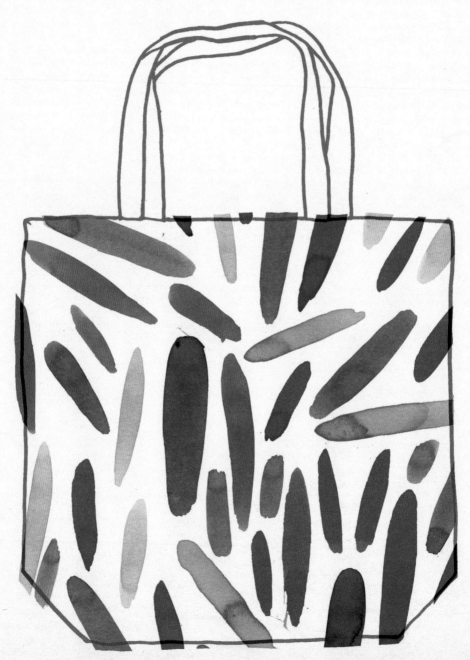

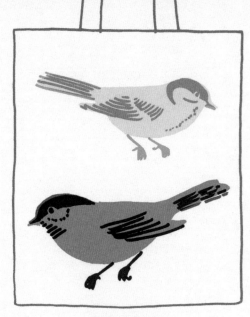

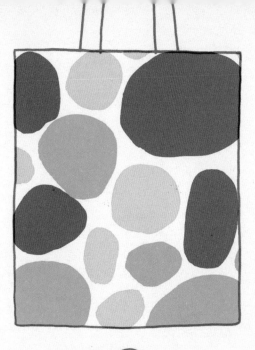

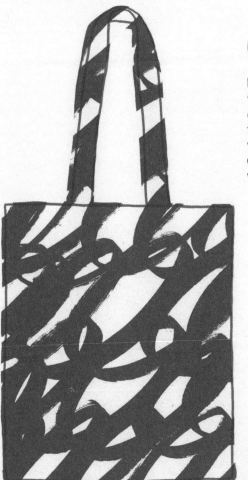

TiP

Fabric pens work like ordinary felt tips and are suitable for use on most natural and man-made fabrics – you just fix your design with an iron once you're finished, and then your bag can be washed with the rest of your laundry!

HAND-LETTERING ALPHABETS

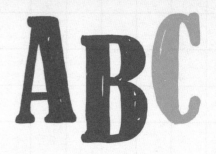

Felt tips and markers are a fun way to try out hand-lettering; either for the first time or to develop your skills. Letters can be drawn in many styles and of course everyone's handwriting is different!

Think about different styles you can draw your letters in; they could be regular or italic, thin or bold, capital or lowercase, joined-up or scribbled. Use as many colours as you like and mix them up to give some of your letters shadows to make them look more three-dimensional.

Tip

If you are writing more than one word, think about which ones you want to draw attention to – you can make these bigger or use uppercase lettering to give a sense of hierarchy or variation.

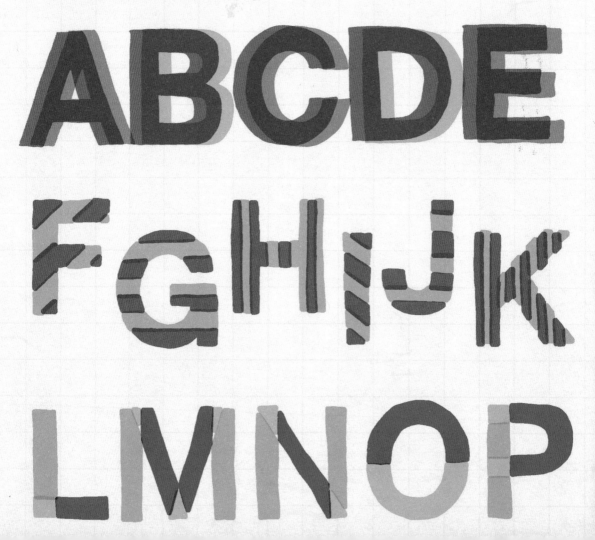

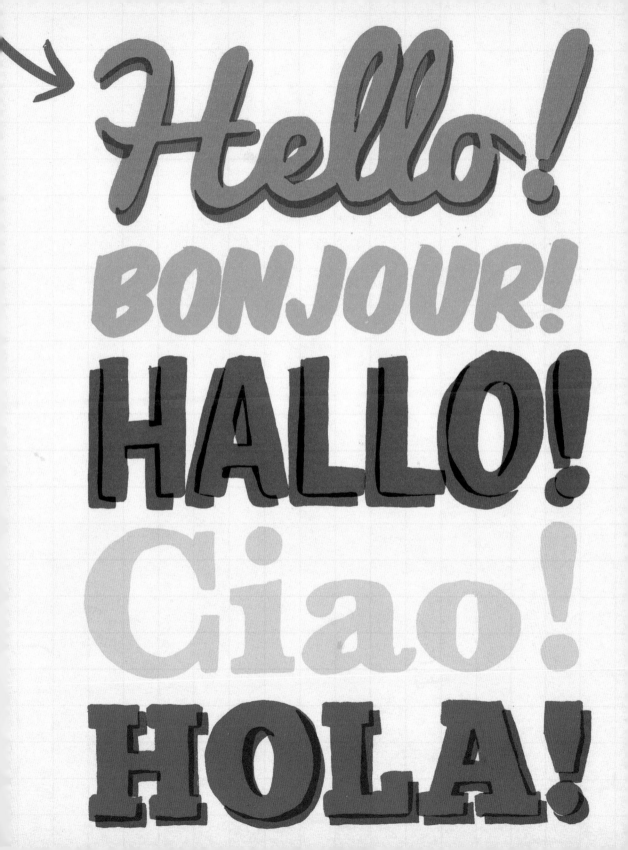

FELT-TIP RESIST

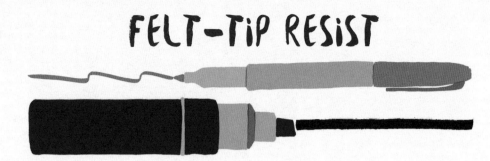

A resist is something that is used to create a pattern by protecting parts of a design. Here is a simple cheat's version that works with felt-tip pens. First, design a really bright geometric pattern using your felt tips. It can be any size, but the bigger the better. Avoid too many large areas of white; colour everything in until your page is as full as possible.

Then get the biggest black marker pen you have in your pencil case and draw right over the top of the pattern with a new design. Here I've made a simple ABC, but it can be anything. Just make sure you leave plenty of gaps for your colours to shine through!

Don't worry too much about your first attempt; this is one of those exercises you can experiment with again and again to get different results, and of course, practice makes perfect.

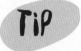

Tip

If you are nervous about ruining your pattern by drawing over it, try drawing outlines of your black design in pencil first then filling in the shapes with the black marker – the principle is all about colouring outside lines to create negative space, rather than colouring inside to fill something in as you normally would.

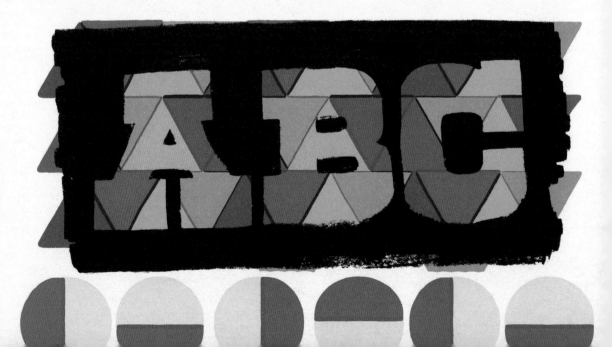

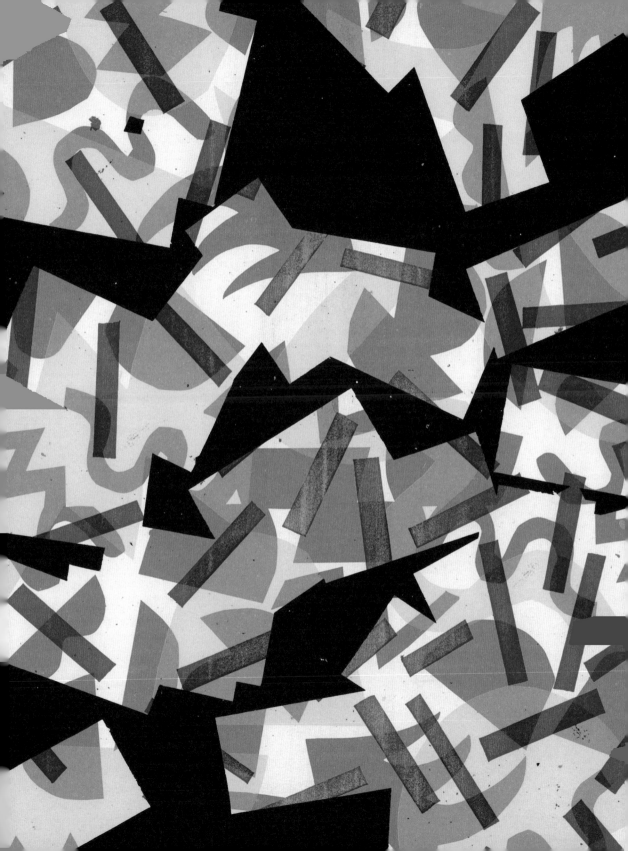

DECORATE YOUR OWN SNEAKERS

Use a mixture of thick marker pens and finer felt tips to decorate your dream sneakers.

Here's how to draw your blank sneaker, ready for decorating.

IDEA

When you've got some designs you're happy with, why not get some fabric pens and try them out on your sneakers for real?

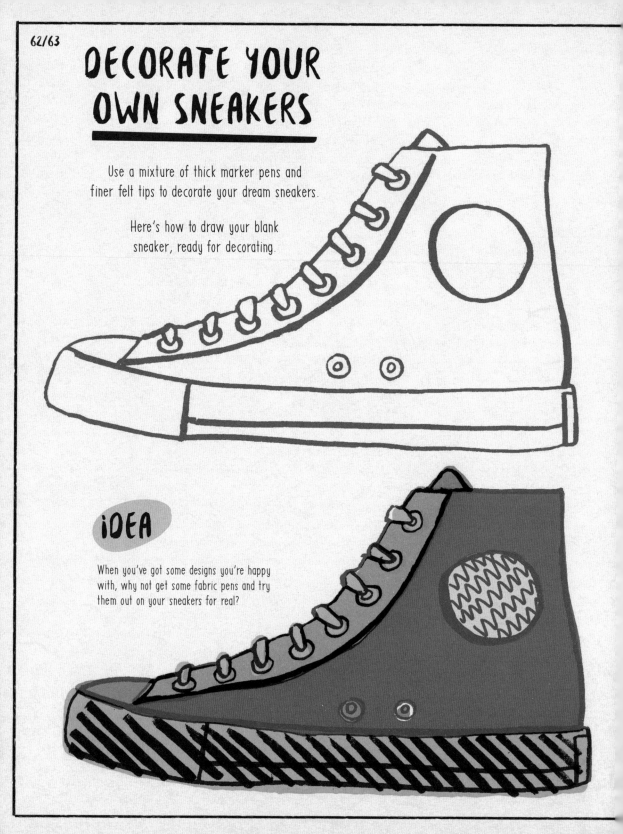

Now to decorate it! Keep it simple – if you layer too many colours your design will look muddy and very dark. Start with light base colours and add just one or two darker ones on top, leaving lots of your base colours showing. Or you can use darker colours but keep areas of white showing – this will help your design pop. Sometimes leaving areas of white paper can help to balance the busy-ness of a crowded design. Look for more pattern inspiration in the book!

Tip

You could also try drawing a different style of shoe from the side to add colour and patterns to. Put your shoe at 90 degrees to you and keep it at eye level while you're drawing it to achieve a 'flat' look.

COLOURED PAPERS

Most of the drawings in this book have been done on white paper, but there are a lot of great effects you can achieve with coloured papers too! Here, I've just used cheap sugar paper – the kind that you can find in scrap books in a variety of colours.

You can get some interesting subtle effects by drawing with your felt tips onto coloured paper, which will often mute your colours a bit. For example, anything you draw onto blue paper will turn out looking a bit more blue than usual and yellow pens on blue paper will come out looking green. Have fun experimenting; see what happens!

Tip

You will find that a white chalk marker pen is particularly useful as it allows you to add highlights to coloured paper – it's how I have drawn these bird silhouettes – and you can draw over the top with any of your usual coloured felt tips.

CUT & PASTE

This is a very similar technique to the 'Magic Patterns' butterflies on page 78, except it's even easier! First you need to colour in some sheets of paper; solid areas of colour work best but you can use any kind of thick pen for this – chalk markers, permanent markers or humble felt tips, they all give slightly different textures.

Next, take some scissors and cut out random shapes from your coloured-in paper. Then take a new blank page and move the shapes around on it until you're happy with the composition – you might even notice that some of the pieces start to look like other things... Plants, fingers and alien tentacles...

TIP

This technique also works well with bold patterns that fill the page. Try and colour in as much of the paper as possible so that the colours and patterns fill the shapes when you cut them out.

HOW TO DRAW FISH

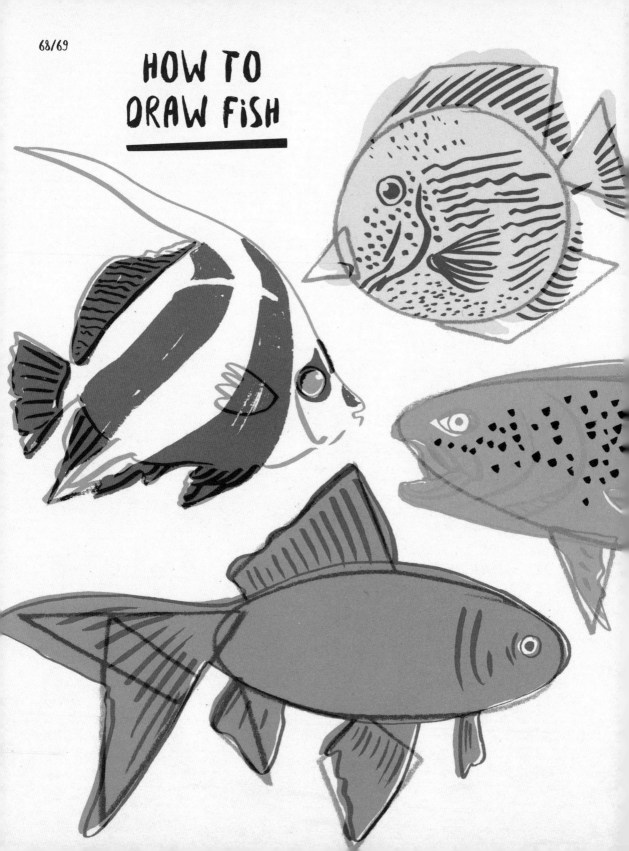

TiP

You might want to find some reference images to work from or for inspiration and refer to page 70 to help you add scales to your fish if you like.

Fish are great fun to draw with felt-tip pens because they come in so many amazing patterns and colours. Here I've focused on tropical fish as they're the most colourful, but you can pick any type you want or even make up your own.

Start off by drawing the overall shape of your fish lightly in pencil, then fill in your shape with a solid colour (lighter shades are better for this, so that the details you add on top will show up). Then add your details in a darker colour – think about eyes, gills, fins, tails, scales and patterns.

TiP

If your pencil marks are still showing, you can use an eraser to get rid of them once the drawing is dry. Make sure the drawing is completely dry or it will smudge.

HOW TO DRAW SCALES

What do fish, snakes, lizards, alligators and crocodiles all have in common? They're covered in scaly skin, and so I have shown the basic principle of drawing scales here so that you can add them to your fish from page 68 or animals from page 94. Your scales can be in any size or shape you like, and I've given examples of round ones and pointed ones to show that the basic idea is always the same.

The principle of drawing scales is similar to drawing bricks: each line is offset from the line before. Break your fish or reptile down into stripes – first draw a row of scales, side by side, then draw the next row offsetting it by one scale. The third row will be in line with the first again, and so on alternately.

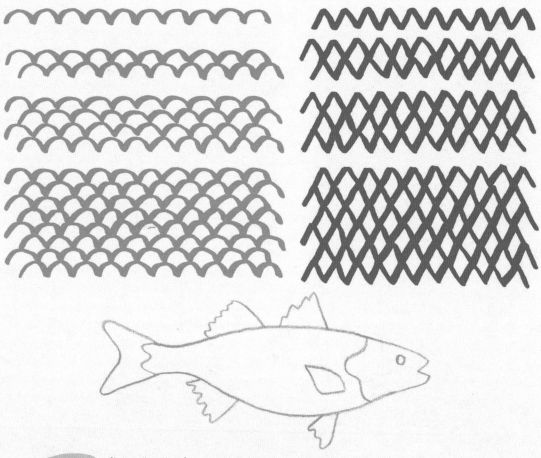

Tip It doesn't matter if your scales look wonky – can you see how by having uneven lines, you can also suggest that the fish or reptile shape is 3D, not flat?

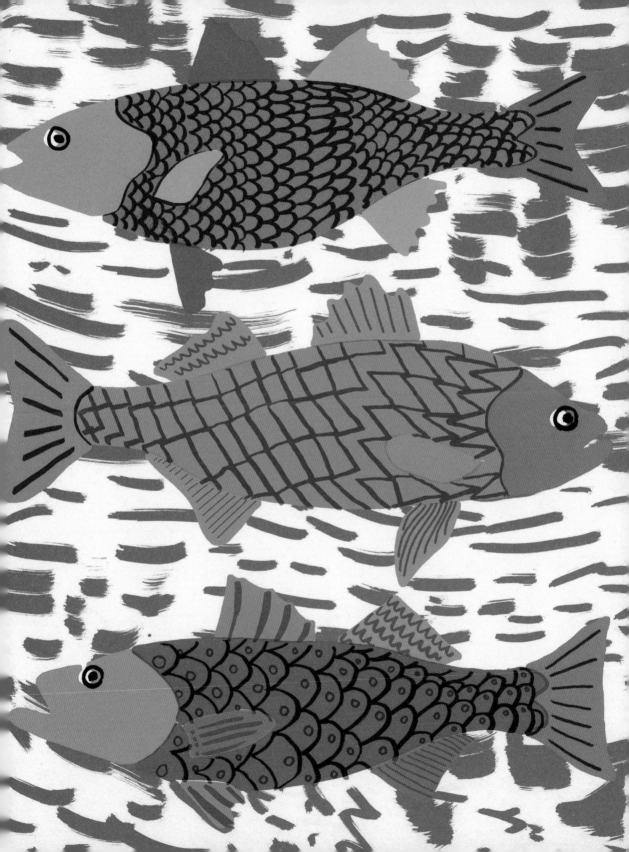

FELT-TiP PORTRAiTS

It's really easy to draw portraits with felt tips! The key is to make your drawings bold, adding just enough detail to suggest who the person is. Think about features like moustaches, beards, curly hair, glasses, and make the most of them!

First sketch out your portrait as many times as you like in pencil until you're happy with the pose. Working from a photograph is a good idea if you don't have a model willing to sit still for a long time.

Mark out the areas where you can see skin, and then the main features of your model/s in a darker shade.

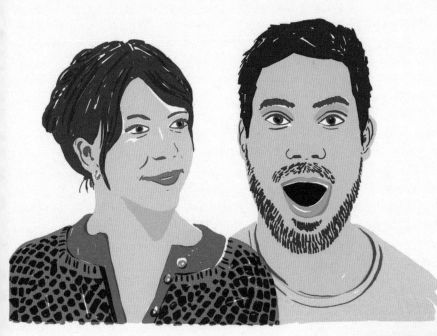

Next, add your coloured detail on top (keep your colour palette minimal for a bolder impact).

Finish off with some background colour too in a few scribbles if you like, to give your portrait some classic felt-tip pen energy!

BUILDINGS

Drawing buildings is easier than you might think. It's all about finding the right pen (depending on the level of detail you want to achieve, you might want to go thinner or thicker) or a few different pens, to mix up textures such as brickwork or panelling with the overall shape. I've shown two basic ways you can draw buildings here – one way is all about line work, the other deals with a bit of perspective for a 3D effect.

1. For buildings drawn as lines, the goal is to draw them front-on only – this could be from a photograph or from life. If you are drawing from a photograph and the view of the building isn't straight-on, simply disregard all the information around the sides and focus on the front facade. Draw the outline of the facade and keep adding detail using line work only – no shading at all, except for doors and windows.

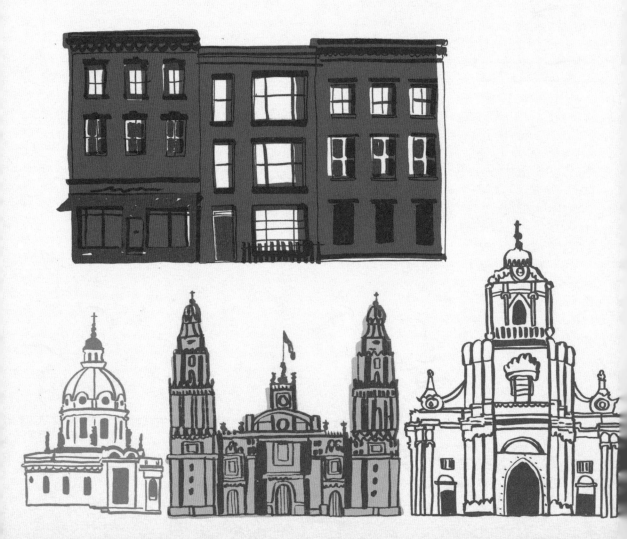

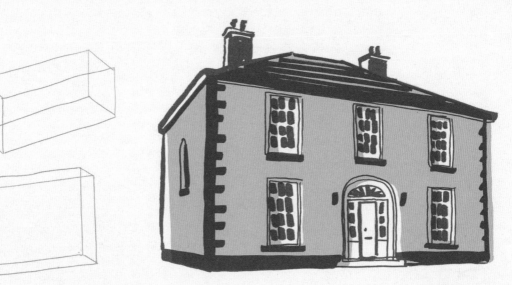

2. For buildings drawn in 3D, break them down into their main block shapes to help you get the perspective right. Look at the angle your building sits on the ground and sketch out 3D shapes in draft first. Keep referring back to the building as you draw for accuracy. Think about your line work and also your shading – which areas will you fill in to suggest depth?

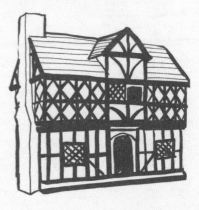

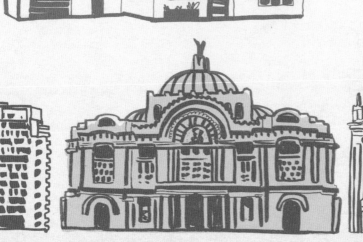

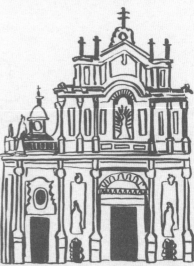

HOW TO DRAW TREES

Pretty much all trees can be drawn based on a simple 'Y' shape. If you draw a Y, and keep adding more Ys to the end of each branch, you'll end up with a tree! You can elongate or squash these Ys to get different shapes of tree. Use thinner lines or finer felt tips the farther towards the ends of the branches you get.

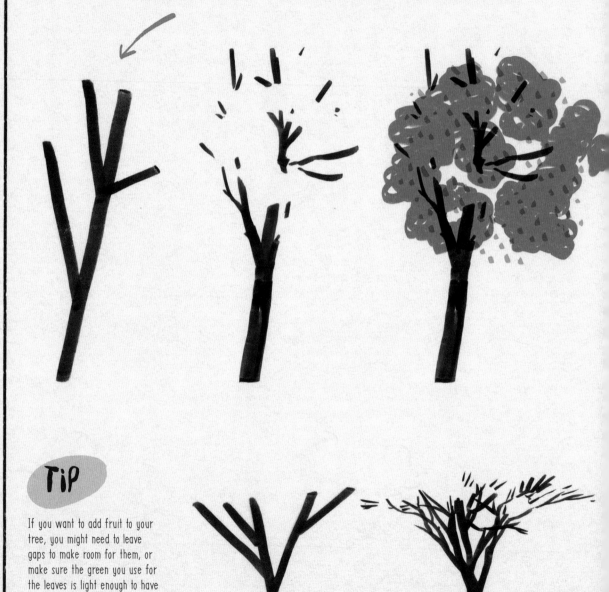

Tip

If you want to add fruit to your tree, you might need to leave gaps to make room for them, or make sure the green you use for the leaves is light enough to have fruit drawn over on top.

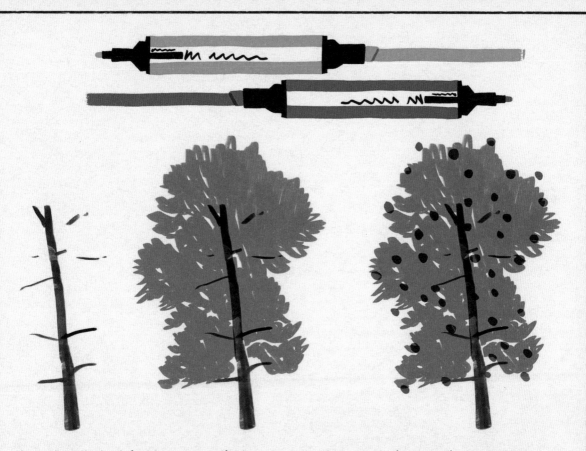

Always draw the trunk first to give yourself a basic plan. Once you're happy with it, draw it again in more detail, this time leaving some gaps between the branches for where your foliage is going to sit, so you can make it look as though it is weaving around the branches. When the trunk is completely dry (as there's a big risk of smudging!) add your green foliage, leaving some small white gaps to suggest the effect of light filtering through the leaves. You can also add a darker layer of green for the shadows or add fruit like apples too if you like.

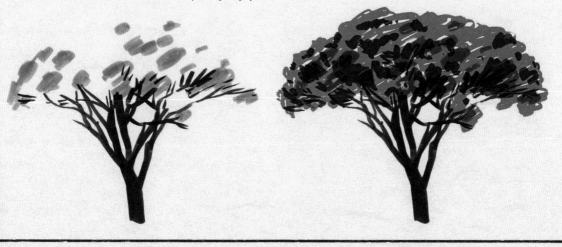

MAGIC PATTERNS

I love collage almost as much as I love felt-tip pens. There is a surprise element to using collage – something unpredictable about the process that means you don't know what you're going to get – but you're also limited by the pieces you've cut out.

Here is a super-simple exercise to make pieces to collage with. All you need to do is draw one big repeat pattern (it can be made up out of lots of different repeat patterns) on a single piece of paper. Here, I've used a piece of pink coloured paper to draw on, as I like the way it works with the rest of the colours too.

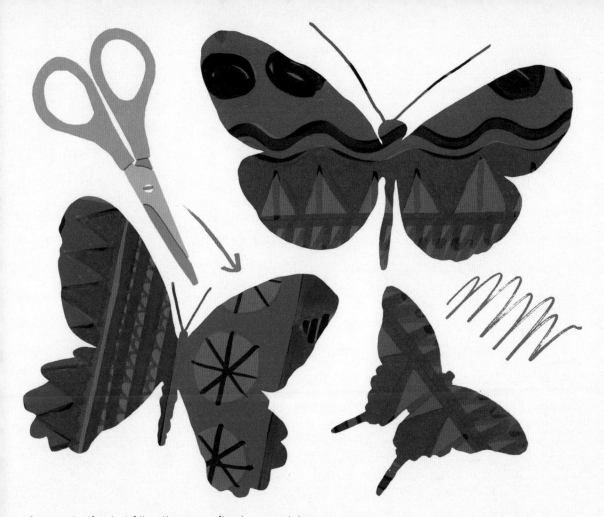

Once you've finished filling the paper, flip it over and draw as many different butterflies of different sizes on the back. Carefully cut around each one with scissors. Flip the butterfly shapes over when you're done and you'll have some fantastically unique patterned butterflies!

When you have all of your cut-out butterflies, you can take a new piece of paper and arrange them. Stick them down any way you want to make a fun collage.

TIP

If you want your butterflies to last longer you could draw them on coloured card instead of paper.

KALEIDOSCOPIC PATTERNS

I like to think of these patterns as the images you see when you play with a kaleidoscope as they're extremely versatile – you can make up new ones simply by changing the colour you're using or adding an extra shape.

The idea behind these kaleidoscopic patterns is all about layering; I've kept them pretty simple – each one is made up of just three different geometric snowflake shapes.

Draw your first snowflake in the lightest colour, the second snowflake directly on top of it in a mid-tone, and the third snowflake on top of both of the previous ones in your darker colour. Make sure each colour is dry before you add the next!

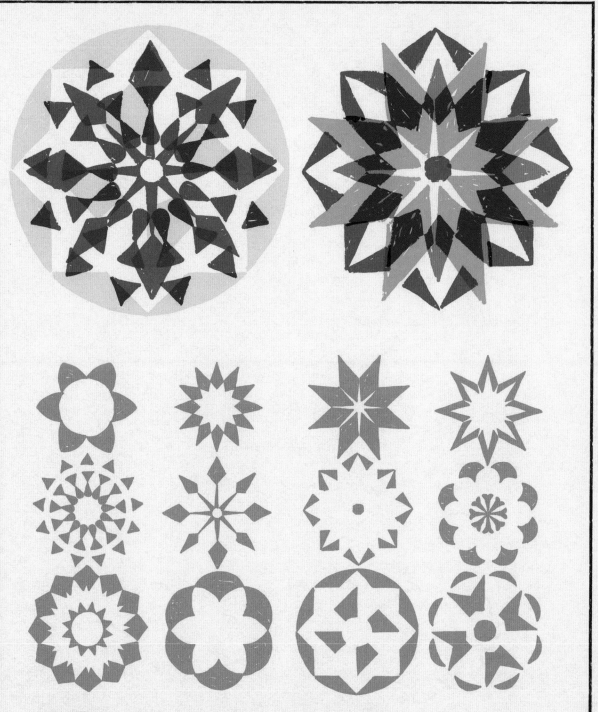

Tip

I recommend drawing out the shapes lightly in pencil first, so that
you get the three snowflakes aligned perfectly on top of one another.
Here are a few examples of snowflake shapes to give you some ideas.

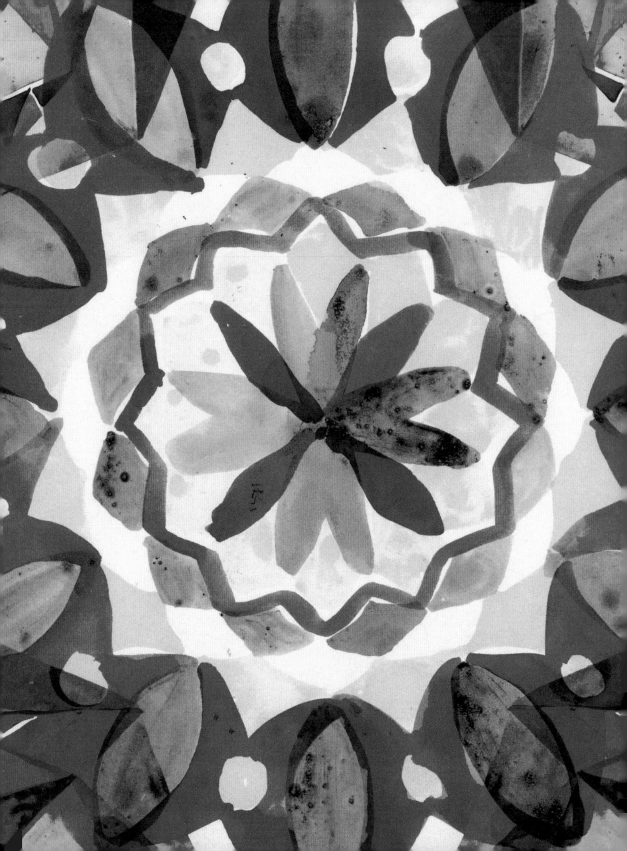

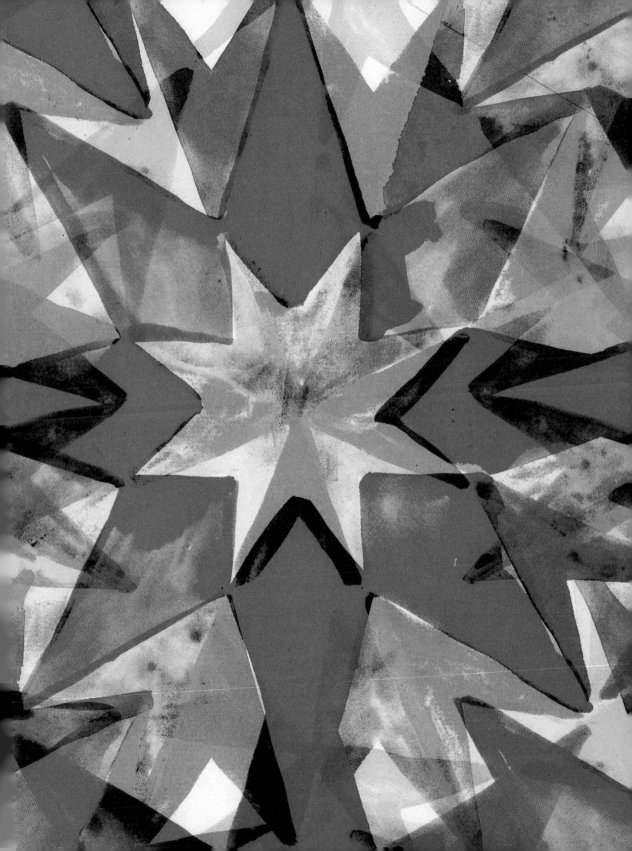

RUBBER STAMPS

To make rubber stamps all you need is a pack of pencil erasers. I use the white rectangular sort which have a plastic finish – you can use any type, but the softer, rounder ones are more likely to crumble when you cut into them.

You can make a stamp of any design you like, but the technique I'm going to show you uses simple geometric shapes as they're the easiest to cut. The idea is that you make a collection of simple shapes, and use them together to make more complex patterns.

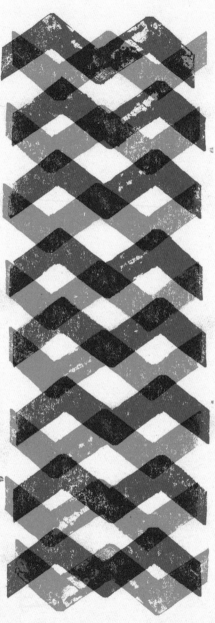

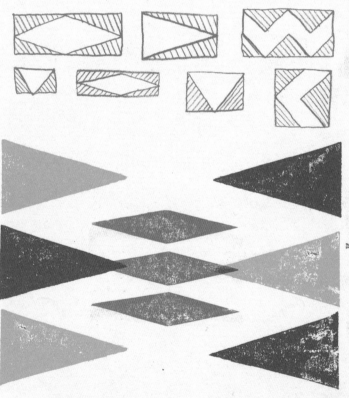

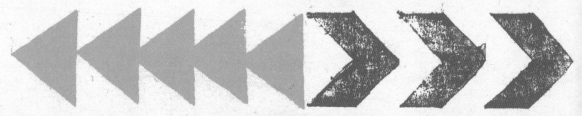

TIP

The bigger the eraser the better – you can have more fun cutting out more detailed designs.

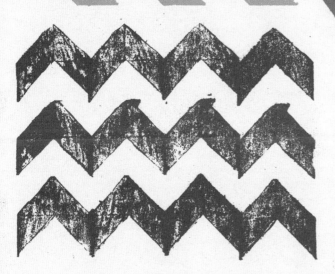

TIP

I'd recommend starting by making large, deep cuts with your scalpel from above, cutting straight down into the rubber along the lines to keep your design sharp, then cutting sideways into the rubber to meet the downward cuts. The pieces you don't want should start to fall away. Be careful when using a scalpel! If you slip, it's going to hurt! Take it slow.

Start with a fine pen or pencil and sketch out the shape you want onto your eraser, using a ruler to keep your lines straight if need be. Then take a scalpel and begin cutting away at the rubber. If you look at the example drawings on the left, your goal is to cut away the shaded areas so that only the white areas are left as raised parts.

Once your stamp collection is ready, you can 'ink up' each one as you are ready to use them by colouring in the shape in one flat colour using a felt tip – the more inky and liquid the pen the better, so I recommend a brush pen. You'll have to keep loading up the rubber with colour each time you stamp to keep the pattern consistent. If you want to switch colours, wipe your stamp first with a damp cloth to avoid mixing colours.

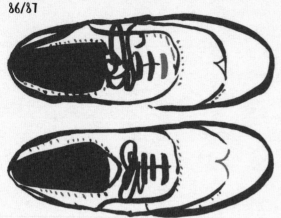

LiNES ONLY

I love bold, bright areas of colour but it can be fun to celebrate lines all by themselves too! Here, I've used a mixture of fine felt tips and brush pens to make these drawings. When you're drawing with lines only, it's all about working out which details you can leave out, and which you should include. When I was drawing these cameras for example, I was thinking about what makes a camera a camera and emphasising the 'camera-like' qualities through my line work alone.

TiP

Line drawings can be layered on top of each other to great effect – try changing the colour of pen you're using with each one.

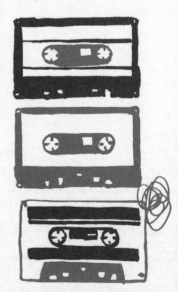

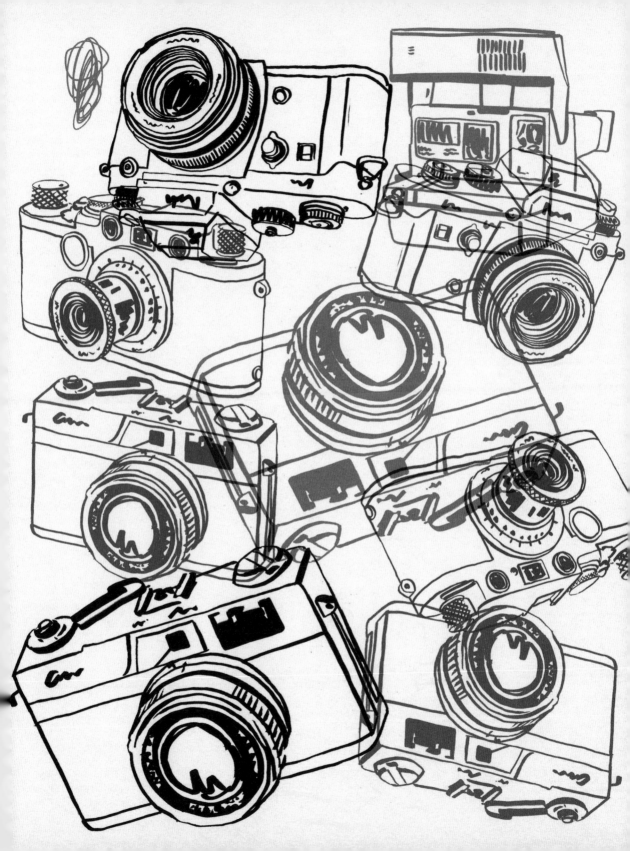

GEOMETRIC BORDERS

You can use geometric patterns to make borders by building them in one direction. Repeat your pattern in the same ways as on pages 24 and 26, except this time go only left or right, up or down. Once you're happy with it, you can copy the pattern or continue it around the page to create a frame.

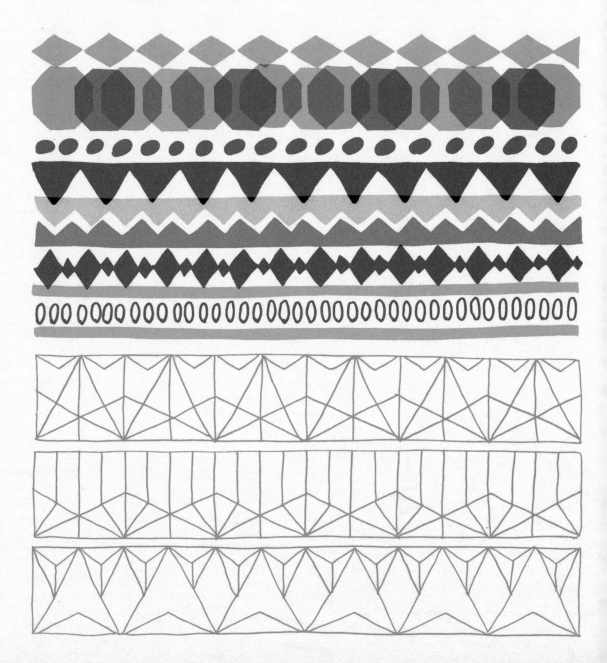

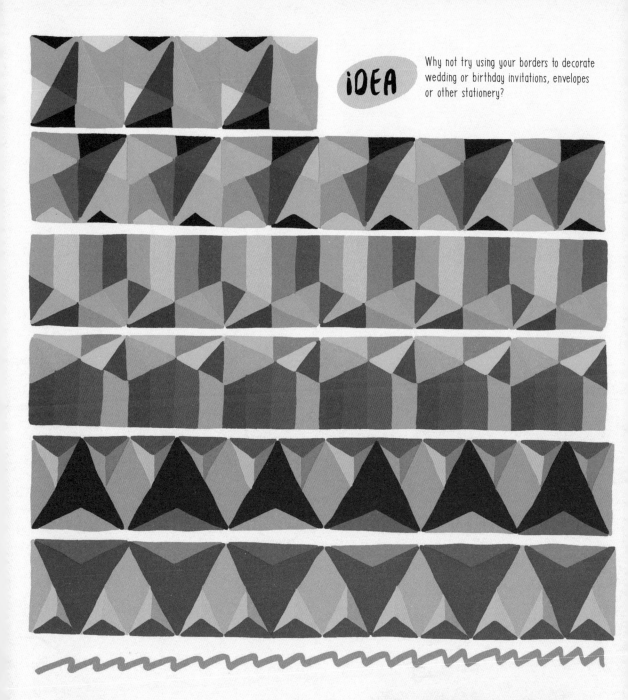

iDEA Why not try using your borders to decorate wedding or birthday invitations, envelopes or other stationery?

TiP Your design doesn't have to go all the way around the page - you might just want to top and tail some text, have borders at the sides or have a decorative strip as an accent.

CiRCLES

It's quite incredible what you can do with just one shape. It doesn't need to be a circle - you can opt for a triangle, square or even a hexagon! The idea is all about repetition; making slight adjustments to each shape as you go, such as cutting it into halves or quarters, changing the colour or changing your pen. Play around to see how many different variations on the theme of the shape you can come up with to make a design.

Tip

As always, start with your lighter colours and work towards darker colours as you layer up your shapes.

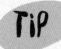

Tip

Chalk markers are also great for layering shapes as they create an opaque layer - try using them on top of each other and watch your previous shapes drawn underneath begin to disappear!

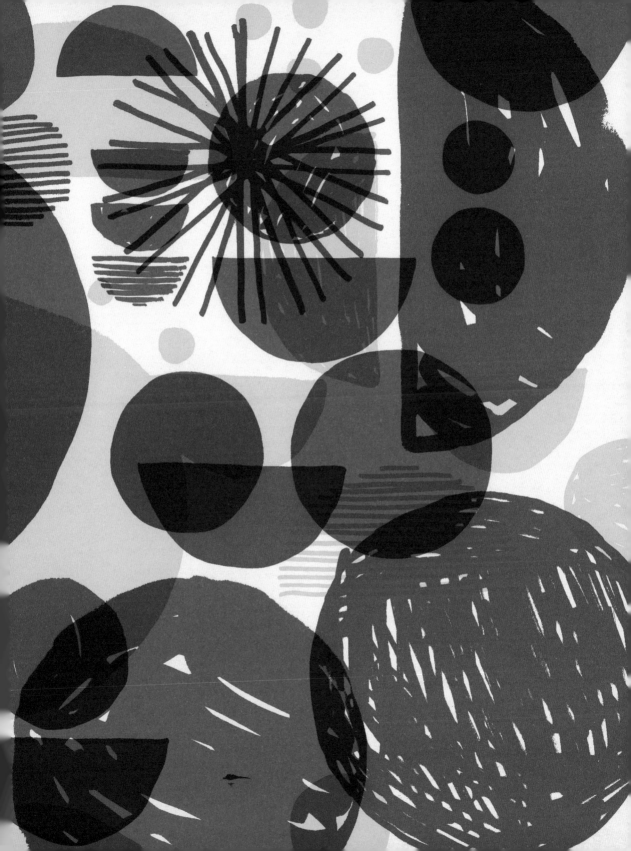

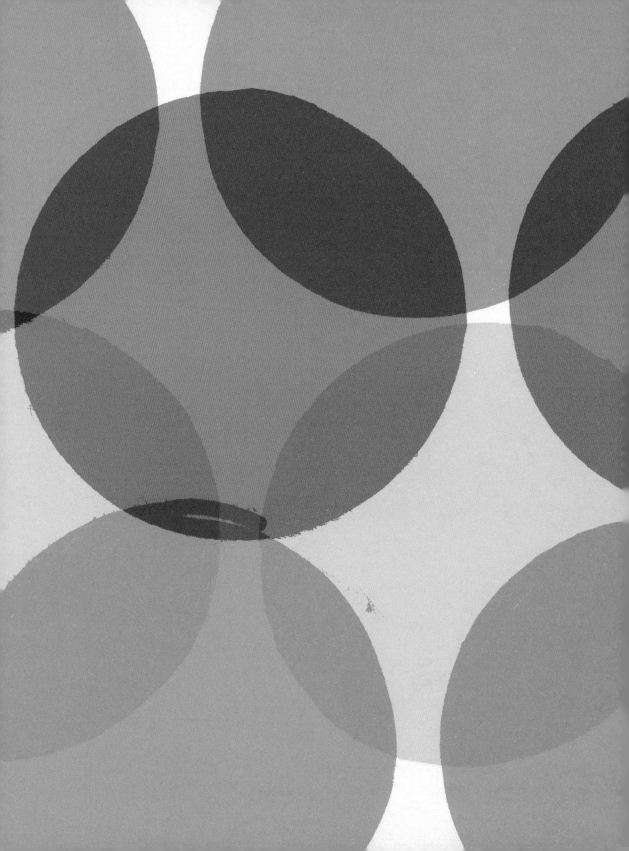

HOW TO DRAW ANIMALS

These are by no means all the animals you can draw! But I chose some of my favourites to get you started.

The principle is always the same – find a reference image to work from that you like, whether it's one of your own photographs or an image from a magazine or online. Then sketch out the general shape of the animal using basic shapes like ovals, triangles and rectangles. Next, use this general shape to fill in the animal's silhouette in a few different colours (you might want a darker colour for the head and tail, and a lighter colour for the body for example). Lastly, add the details such as eyes, ears and markings.

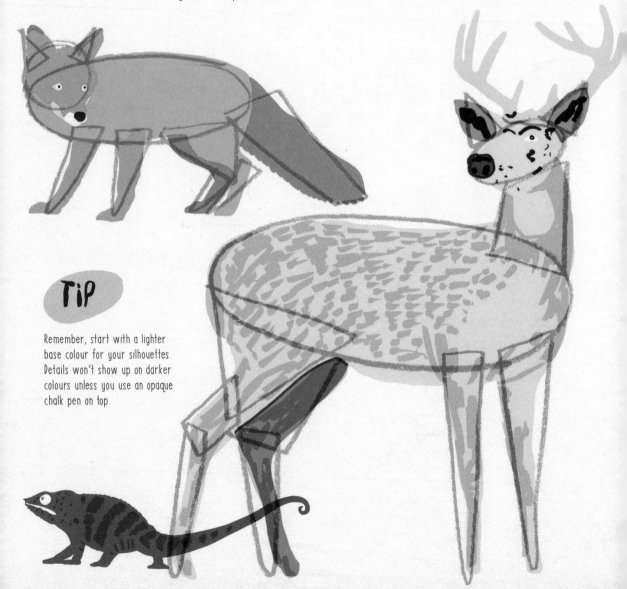

TiP

Remember, start with a lighter base colour for your silhouettes. Details won't show up on darker colours unless you use an opaque chalk pen on top.

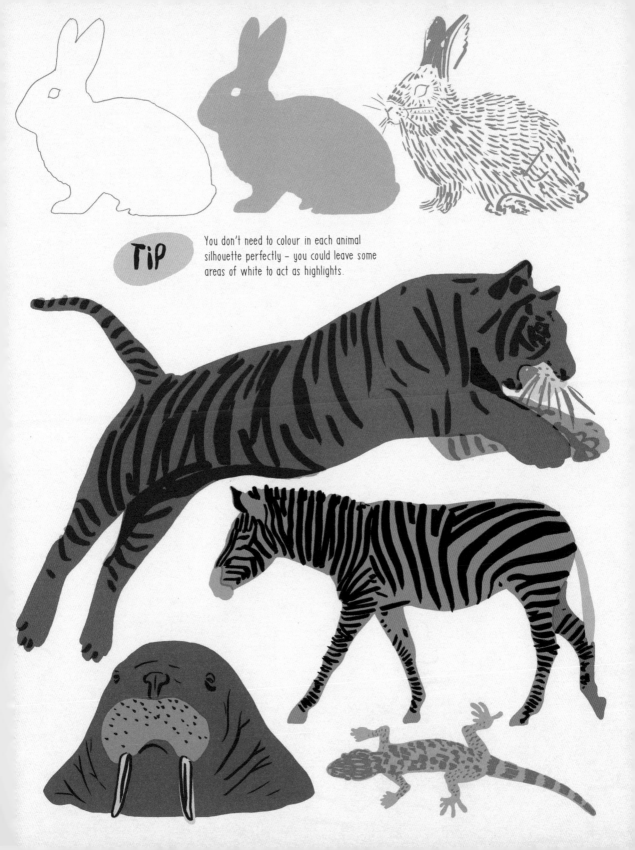

Tip You don't need to colour in each animal silhouette perfectly – you could leave some areas of white to act as highlights.

NEGATIVE SPACE

Negative space is the space between the positive objects in
an image (here, the positive objects are the lamps). I see it
as being like the opposite of a silhouette.

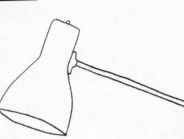

Try finding an object or a scene that you like and blocking out
everything except for the thing itself with one shade of colour.

TiP

It might help you to sketch out a rough outline
of your shape first, and then colour around it
to achieve the effect.

iDEA

You can always work back into the negative
spaces with details and patterns to create
interesting decorative or abstract images.

A DAY AT THE MUSEUM

I love drawing from life – it's a great way to get inspired and out of your comfort zone. Museums are perfect for this as many are happy for artists to bring their sketchbooks and drawing materials to sketch the exhibits at their leisure. Take a small selection of pens (you don't want to litter the museum floor with your entire pencil case!) and a hardback sketchbook that you can lean on for support.

Draw the things that interest you – look at the patterns on ancient pots, the texture of marble or shadows created by different kinds of sculpture.

TiP

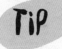

You can add shadows quickly and easily using lines or by overlapping a similar shade to your base colour where you need it.

DECORATE YOUR OWN SUNGLASSES

Draw your dream pair of sunglasses and decorate them with colourful felt tips however you like! Think about the shapes and patterns of the frames; they can be elegant, crazy or bold – anything from heart-shaped, tortoiseshell effect or polka dotted! Here are some ideas.

IDEA

Why not use the same technique to decorate masks for a party? Just draw out your designs on card, cut out holes for your eyes and either attach a stick to hold it up in front of your face, or some elastic at each side to wear it.

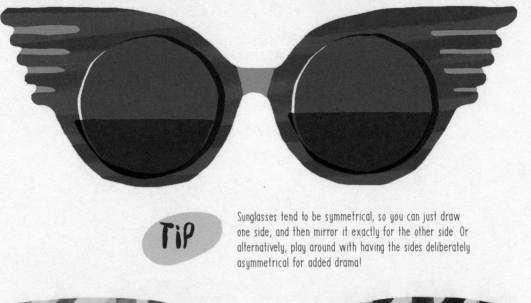

Tip

Sunglasses tend to be symmetrical, so you can just draw one side, and then mirror it exactly for the other side. Or alternatively, play around with having the sides deliberately asymmetrical for added drama!

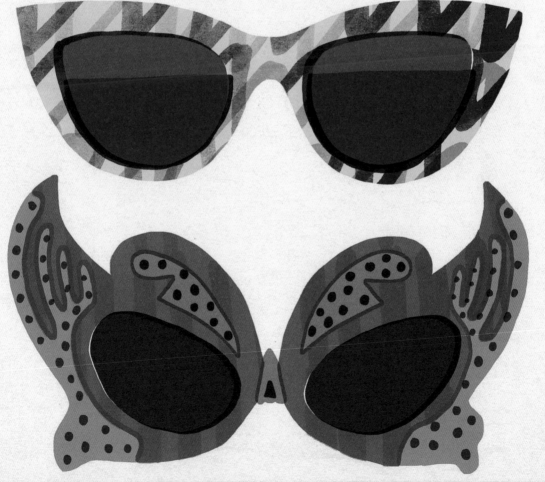

THiCK & THiN PENS

It can be important to choose the right felt-tip pen for the job to make your life easier and achieve the best effects! Thick and thin pens can work together in perfect harmony – for these vehicles, I drew the shadows and block shading with fat marker pens, and the line work and details with fine felt tips.

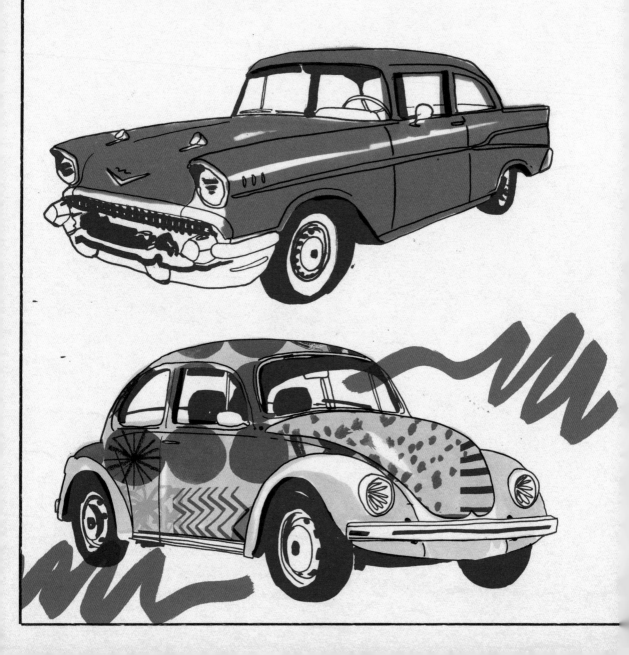

Try drawing your own car, favourite vintage car or supercar – it could even be a bicycle if you want! First draw just the line work using a thin pen and block out the shadows of your subject with a thick dark marker.

Then add colour or pattern using a variety of thick and thin pens. Notice the range of effects you can get and how you can create a more sophisticated drawing by mixing up the thicknesses of your pens.

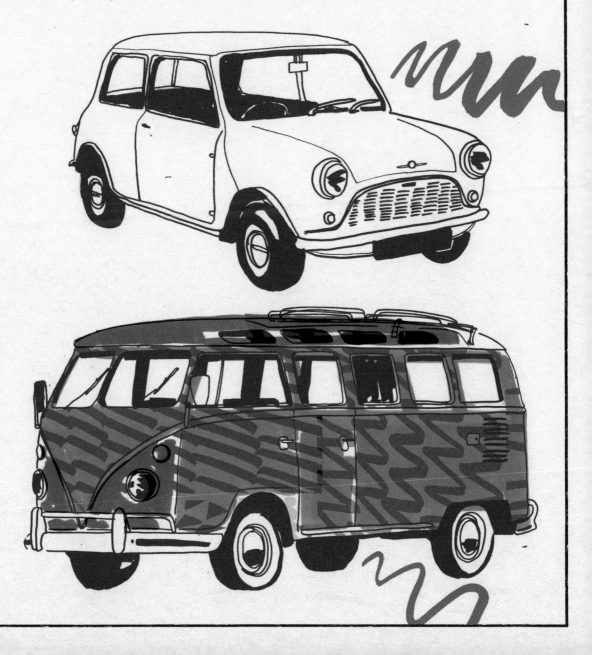

LEAVES

Leaves come in all shapes, sizes and colours.
I've drawn lots of different varieties here to
give you some inspiration, but what you do
with yours is up to you. They are well-suited
to a repeat pattern or a more detailed
drawing of just one or two leaves.

iDEA

I've drawn my leaves in fairly realistic colours, but how might they look if you made the colours more unconventional? You could also add multicoloured patterns to your leaves, and even cut out some patterned leaves using the same technique as for the 'Magic Patterns' butterflies on page 78 to make a collage.

TiP

Think about what makes a leaf – dry leaves curl up at the edges so you might see the other side, and some leaf veins are very prominent while others are almost invisible.

DRAWING THINGS IN MOTION

IDEA

Why not try making a flipbook? Cut pieces of paper to the same size so that they make a small book and glue them together at one edge. Then use your felt tips to draw your subject changing slightly each time from frame to frame.

Felt tips, especially brush pens, are great for drawing things in motion. From sweeping textures on hair and fur to motion lines surrounding your subject, it's really easy to make your drawings look dynamic just by using quick, bold strokes.

Here is a drawn sequence of one run cycle of a tiger, inspired by the still images of pioneering photographer Eadweard Muybridge. Look at how the legs come together underneath the body before stretching out again in both directions. If you watch your own pet running you'll see the same thing happening.

Try drawing as quickly as you can from life or from a video; don't worry if you don't capture all the details – it's more about capturing the essence of the movement. Use energetic, bold marks, and be prepared to go over the same areas multiple times.

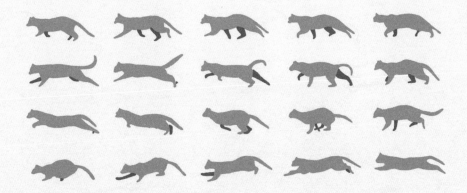

FRUIT & VEGETABLES

Fruit and vegetables are fun to draw – start with your menu favourites and go from there! Try drawing some of them upside down or different ways round by turning the page before you start drawing.

TIP

Think about the marks you could use to show the textures on things like gourds and pumpkins, or to show the amazing patterns in a Romanesco cauliflower or half a lemon.

Make a basic sketch of your fruit or vegetable first in pencil, then divide it up into the areas that will be shaded in different tones. Use your sketch as a guide to make a copy of the fruit or vegetable that doesn't have any pencil guidelines, because if you just colour directly on top of the pencil you won't be able to erase it afterwards!

TiP

With this technique avoid outlining shapes in a darker shade of pen – it's all about making the most of block areas of colour to bold effect. Save your finer pens for adding details, such as for salad leaves or an onion skin.

DRAW ANYTHING IN THREE COLOURS

When working with felt tips, limiting the number of colours you use for a drawing can be much more effective than layering or blending lots of different ones. Here, I've used just three colours, and the idea is to think about how the colours will work separately and also when layered.

Start by drawing something you like in pencil. Add your first colour – the lightest of your three – wherever there are highlights. Wait for this layer to dry before adding your second colour for the areas that are in a mid-tone. Wait for this layer to dry too and then add your darkest colour to mark any details and shadows. Use bold strokes and don't worry too much about how accurate you are – these marks give the drawing energy – but less is more!

Tip

Leave small gaps when you are colouring so that the white paper shows through – free highlights!

Tip

Use a lightbox or some tracing paper to help you trace the layers as you're drawing if you need to. Felt-tip pens take a bit longer to dry on tracing paper than ordinary paper though, so you will need to wait longer for the ink to dry to avoid smudging.

DOODLE CHARACTERS

These are the easiest drawings to do of all! Scribble as many random shapes in a variety of sizes and colours as you can to fill your page. Then take a fine felt tip and have fun transforming your blobs into a host of characters. It's a bit like looking for faces in clouds – once you spot one, you won't be able to ignore it!

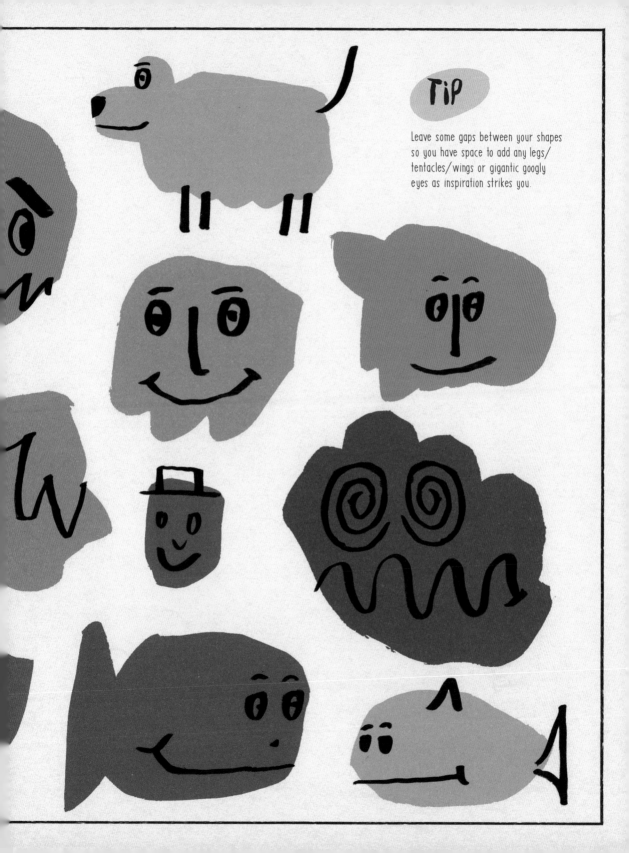

TiP

Leave some gaps between your shapes so you have space to add any legs/ tentacles/wings or gigantic googly eyes as inspiration strikes you.

ILLUMINATED LETTERS

Illuminated letters are used to decorate manuscripts, and although it's only letters in gold and silver that are considered truly 'illuminated', we can use some poetic licence! Use the brightest colours in your felt-tip collection and try drawing some illuminated letters of your own. You can decorate your letter backgrounds however you like, whether that's with a traditional floral design that could be symmetrical or not, or just filling the space with lots of flourishes, swirls or small pictures.

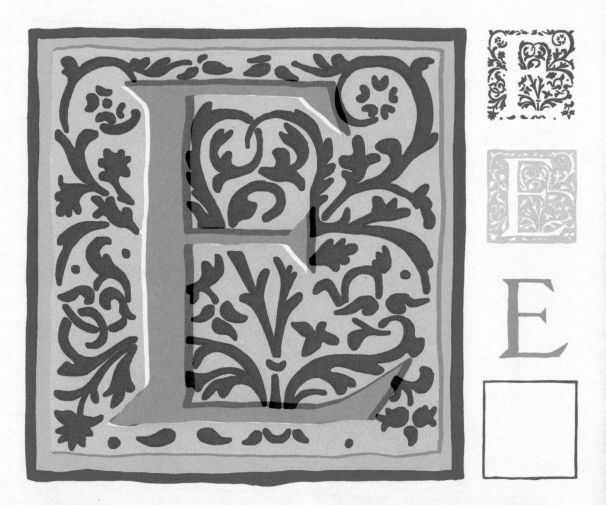

Use the initials of a friend to make a great birthday card!

Illuminated letters are traditionally bound within a square or rectangle, but you can try circles, triangles or hexagons too!

Tip

You can try tracing over your illuminated letters and picking out the background in a single colour to make a version of your letter showing just the negative space.

SWEET TREAT GIFT TAGS

Ice creams, cakes and biscuits make the perfect things to draw with your felt tips because they're all so colourful! Draw your favourite sweet treat as a single drawing or repeated pattern using bright, bold colours. Then think about how you can cut out your drawing to make a fun gift tag or small note card that looks good enough to eat. Have fun playing with close-up crops and strange crops where it isn't clear straight away what the drawing is meant to be of!

Tip As always, start with your lightest colours first, and layer them up so you're using your darker colours last. Add shadows by using a pen in a slightly darker shade of the same colour as the one beneath it.

Tip

You can make more than one gift tag from an image if you crop it into halves, quarters or even more pieces!

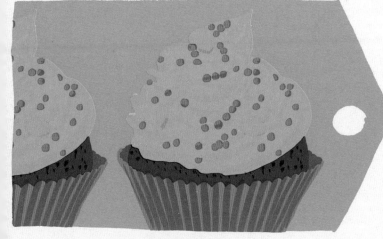

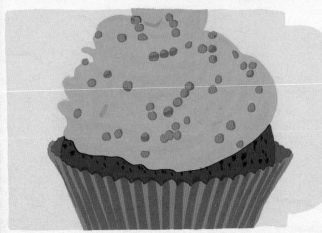

BACKGROUND PATTERNS

Make big, bold strokes with your biggest pens to create
exciting backgrounds! Take a page and fill it – scrawl scratchy
marks, make patterns out of giant shapes, overlap bright colours,
use coloured paper, use your white chalk marker to add highlights,
or cut shapes out with a scalpel; anything goes as long as you think
big! Work quickly, and move onto the next page before you become
too precious. These are great designs as they are or you can cut
them up and use them as borders, to decorate envelopes,
or even as textures and backgrounds in other illustrations.

TiP

Think about using contrasting colours – they'll give the biggest impact.

TiP

You could try introducing some collage to these patterns too – try tearing some white paper into small pieces like I've done here, and sticking them to your background. Then, if you draw over the top, you'll get some interesting effects where the ink appears differently against the various colours and white paper.

DRAW YOUR OWN TREASURE MAP

There's treasure to be found, and you're going to draw the map to find it! Your map can be of anywhere you like – your house, your town, or just somewhere you've made up!

Draw out the lay of the land to make your map shape, and add some landmarks and treacherous obstacles – they could be the traditional palm trees, sea monsters and octopuses or more personal objects and buildings that are important to you. Draw a treasure chest or a big 'X' to mark the spot where the treasure is, and add a dotted line to show the best way to get to it.

Tip

Don't forget to add a compass rose and handwritten comments over your map to make it look really authentic!

Idea

It could be fun to hide a present for a friend and draw them a map to find it!

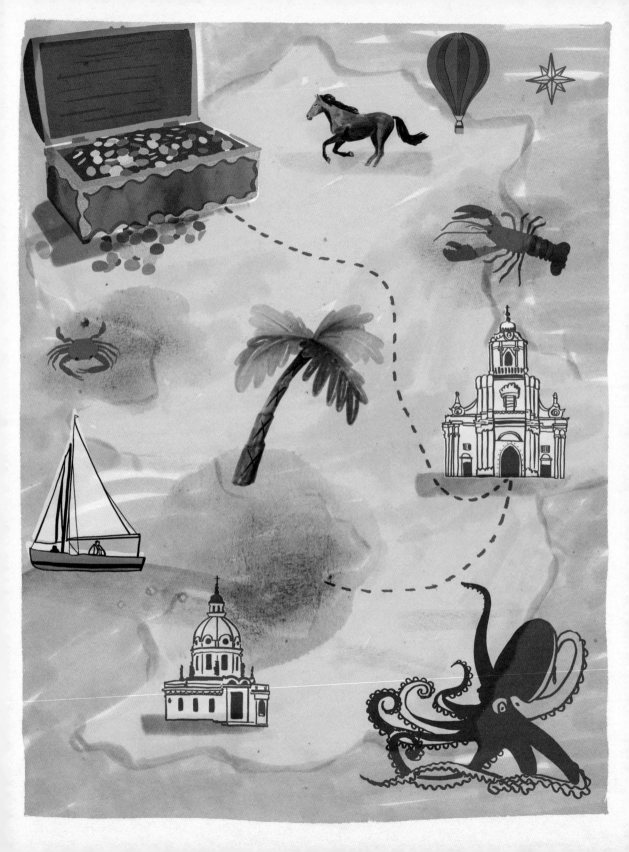

LANDSCAPE POSTCARDS

You can have fun making postcards whether you're travelling or not! Cut a piece of card to postcard-size (it can be any colour) and mark out the lines for the address and stamp on one side.

Then flip the card over and get creative! If you're on holiday you could draw the view, or if you're at home you could draw a scene from your imagination or from a photograph of your dream location. Sketch out your landscape in your sketchbook first so that you know how it will look. Once you're happy with your design, mark out on the postcard the main areas that you are going to colour in. You could do this lightly in pencil first so that you can erase your lines later, or dive straight in with your felt tips if you're feeling confident.

When you're adding colour, start with the areas of your landscape that have the most detail - this might be trees, people, buildings or even a table laden with food - then fill in the foreground and background around them.

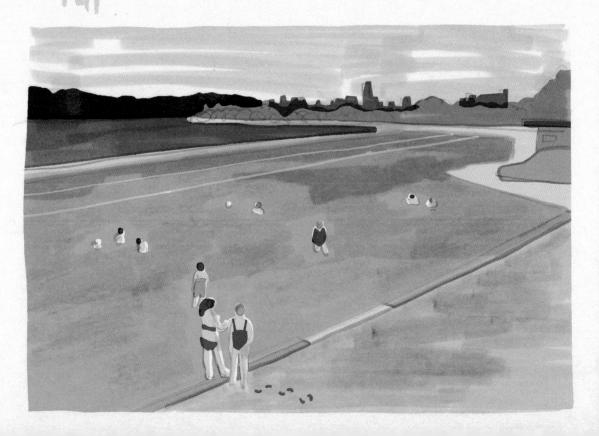

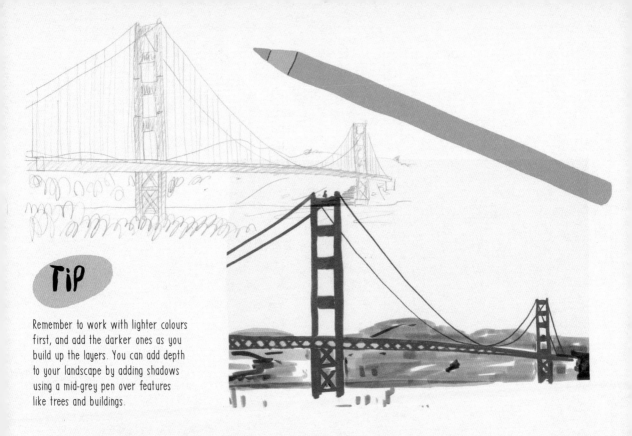

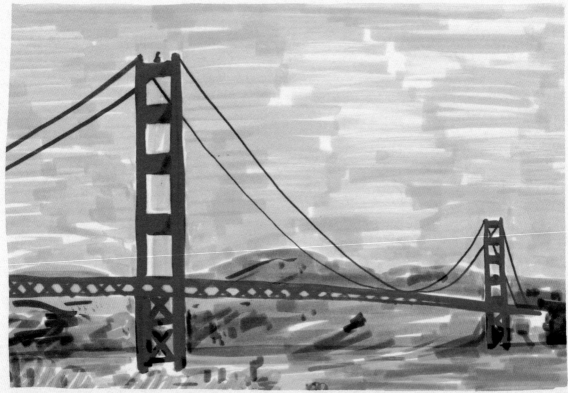

LETTERING
FROM AROUND THE WORLD

You can be as experimental as you like with alphabets and scripts in whatever languages you like! You might want to use a calligraphic style or a blocky design; rainbow colours or neon bright ones. If you make the words big enough you can also add details and patterns inside them! These examples all say 'hello'.

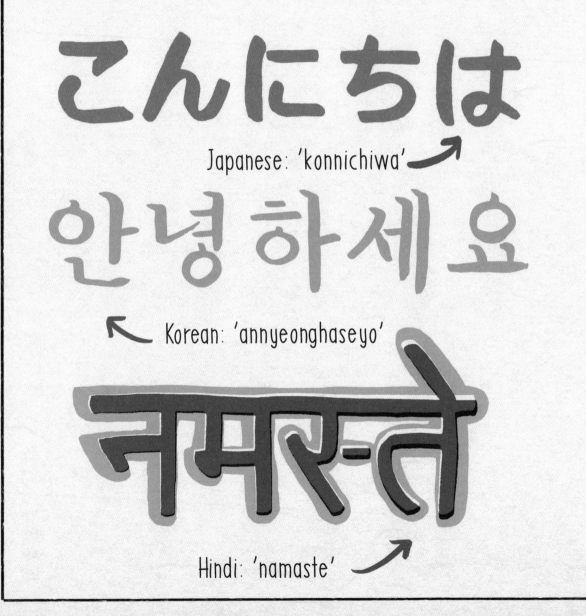

Japanese: 'konnichiwa'

Korean: 'annyeonghaseyo'

Hindi: 'namaste'

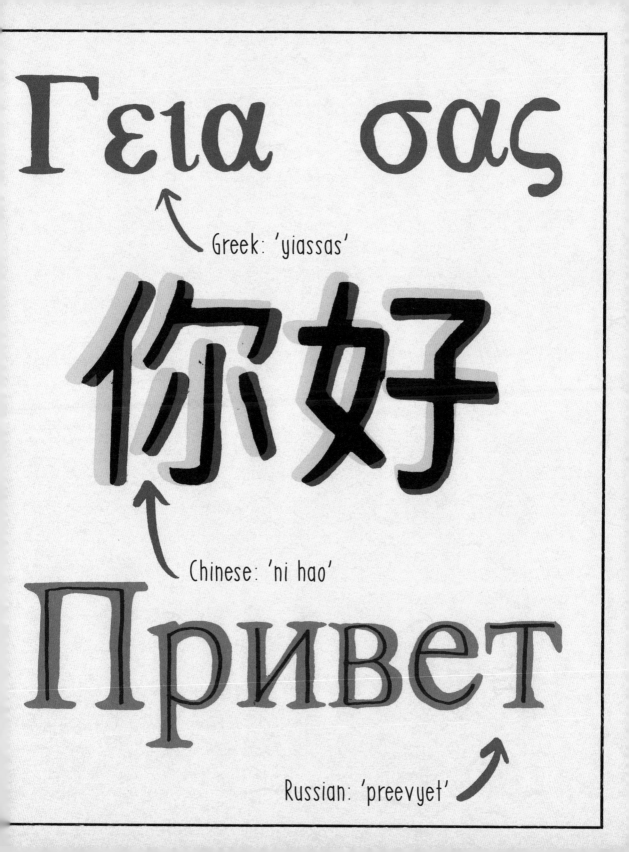

Γεια σας

Greek: 'yiassas'

你好

Chinese: 'ni hao'

Привет

Russian: 'preevyet'

ART MATERIALS

I love felt tips, but what I've shown that you can do with them is just the beginning! There are lots of other art materials that you can experiment with, building on your felt-tip techniques. Here are some ideas:

* You can try using fabric marker pens on textiles – they work like normal felt tips except you can draw onto fabric and then make the designs permanent.

* Try using masking tape to mask off areas of your paper – cut the tape into shapes or stick it in strips onto your page. Then colour over it with a thick marker and, when the ink is dry, remove the tape and check out the results.

* You could use your patterns and backgrounds to make origami or paper models. Or try cutting out silhouettes from your drawings using a scalpel.

* Add a few drops of water to your felt-tip drawings before they are dry, you can then use a small brush to blend the colours as if you were painting with ink.

ACKNOWLEDGEMENTS

Thank you to everyone who has been involved in the making of this book, in particular it wouldn't have been possible without this lot –

Stephen Smith – for the unwavering support every time I claimed I was suddenly unable to draw dogs/fish/trees/buildings, and for the endless fresh coffee.

Sophie Ridding and Pete East for posing so exquisitely to be drawn.

Kirsten Abildgaard for keeping me entertained on a daily basis with videos of goats on skateboards/dogs in hats/synchronized kitten dancing.

Zosienka for pace-setting whilst working on a book of her own and making me feel not quite so alone in the process!

And to every felt-tip pen in the universe, I love you all.

ABOUT THE AUTHOR/iLLUSTRATOR

Holly Wales is a UK-based illustrator. Her client list includes the *Wall Street Journal*, *National Geographic*, the Victoria and Albert Museum, Urban Outfitters, *Wired* and *GQ Deutschland*. Between 2008 and 2013 she illustrated a weekly column for the *New York Times Magazine*.

Holly has also taught at Central Saint Martins, Winchester School of Art, Camberwell College of Arts, Falmouth University and the University of Brighton.